MW00623649

HAUNTED
MOHAWK
VALLEY

HAUNTED MOHAWK VALLEY

DENNIS WEBSTER + BERNADETTE PECK

Haunted
America

Published by Haunted America
A Division of The History Press
Charleston, SC 29403
www.historypress.net

All images courtesy of the Ghost Seekers of Central New York unless otherwise noted.

First published 2011

Manufactured in the United States

ISBN 978.1.60949.266.3

Webster, Dennis, 1966-
Haunted Mohawk Valley / Dennis Webster with Bernadette Peck.
p. cm.
ISBN 978-1-60949-266-3
1. Haunted places--Mohawk River Valley (N.Y.) 2. Ghosts--Mohawk River Valley (N.Y.) I.
Peck, Bernadette. II. Title.
BF1472.U6W434 2011
133.109747'6--dc22
2011015496

Notice: The information in this book is true and complete to the best of our knowledge. It is offered without guarantee on the part of the authors or The History Press. The authors and The History Press disclaim all liability in connection with the use of this book.

DENNIS: This book is dedicated to those who seek answers for the unknown, lovers of the mystery, seekers of the spirit and all who partake in the quest for ghosts.

BERNADETTE: This book is dedicated to the spirits that watch over us and the hope that everyone everywhere will experience their presence in our world during their lifetime here.

CONTENTS

PREFACE

DENNIS: In the summer of 2008, I attended a presentation by the Ghost Seekers of Central New York (CNY) at the Oneida County Historical Society in Utica, New York, where I sat in the first row of a packed house. Bernadette Peck and the rest of her seasoned team enthralled the audience with their findings of paranormal investigations conducted in homes, churches, cemeteries, pubs, jails and battlefields. I sat in stunned silence as I listened to the electronic voice phenomena and looked at pictures of orbs, mist and apparitions. The scientific equipment they use was unparalleled, and time was taken to explain the technical specifications, usage and results. This was a passionate display by ghost seekers who knew their craft and displayed the joy and love they have for seeking and archiving the unknown. I went home and sat alone in my kitchen, thinking of events around me that I could not see or feel.

Flash forward to a snowy, dark evening in October 2008 at the Dunkin' Donuts in New Hartford, New York, where I sat and chatted with the Ghost Seekers of CNY. I talked a long time with the leader of this first-class group of ghost hunters, Bernadette, along with her team members Ed Livingston, Leonard Bragg, David Peck, Marlene Marrello and Kathleen Durr. I was enthralled by their kindness, passion and professionalism. This was a serious group doing important work, and their quest is one of significance. I felt humbled to be in their presence as we discussed this book and their willingness for me to tell their tales of the unexplained.

Ghosts and unexplained phenomena require an open mind. Some people among us are born with special gifts of sight, and others use scientific equipment that can reach beyond the spectrum of mere mortals. So sit in a chair in a dark corner, light a candle, cover your lap with a blanket and prepare to be educated and enthralled by the seekers of ghosts.

BERNADETTE: In most ways, I'm just like everyone else, except for the fact that sometimes, since I was a child, I've been able to see ghosts. Some, I believe, are earthbound, while others seem to be able to travel back and forth from another dimension into our earthly world. It all started in my childhood as a visitation from a woman who would appear to me at night in my bedroom. She wore a red dress and had ink-black hair and eyes. She scared me. Who was she? What did she want?

I attended St. Mary's school in New York Mills, New York, for a Catholic education. I felt that the school repressed my gift, and the guilt of being able to see supposedly dead people caused me at times to deny this gift. Of course, seeing the original black-and-white movie *13 Ghosts* excited me and inspired me to think that maybe there really were ghosts. Every adult I knew told me that there was no such thing as ghosts and that it was just my imagination. But I knew what I saw! Then, one day when I was skipping down the sidewalk, I had an epiphany that I did not quite understand. "When I die I'm not really going to be gone. I'll always be right here, alive!" It was so profound then, and at times still is, but now I truly believe it.

Sometimes I would try looking for ghosts in cemeteries and old, abandoned houses. I called them haunted houses. I came to realize that ghosts were everywhere. I wanted to know why.

As I reached adulthood, I was drawn to the ghost world and all things paranormal. I continued seeing ghostly specters, and in 1992, in the home my husband and I built, I was privy to witnessing my first shadow person moving swiftly through the hall. It looked just like the shadow of a living person, except that no one else was in the house other than my sleeping husband. I said, "So this is what I've read about and researched?" There it was, right in front of me, and I felt a little unnerved about it. Not long after that, an apparition materialized right before my eyes as I sat watching television that, amazingly, looked just like my deceased brother Jim, complete with plaid shirt. My father also reported seeing an apparition in a window of this home as we relaxed on the patio. Nobody was in the house. I sometimes believe that my father also possesses the gift of sight

and that I have somehow inherited this gift from him. He is never afraid to talk about his ghostly experiences.

Can you imagine, by now, how my thirst for knowledge and understanding about the afterlife, as well as why some of us don't seem to go or stay in their resting place, had become my passion? Why do some become earthbound and yet others decide to return and visit at will?

After my deceased grandmother appeared and was apparently talking to me with her eyes, not her lips, I decided to find other like-minded people who had experienced the same things that I had. By now I had read every book and bit of material I could get my hands on about this phenomenon. We all had to *want* to seek answers about the world of ghosts that is apparently very much part of our everyday lives.

Some came for thrills and chills, but after years I was able to hand-pick the truly serious and dedicated ones to embark on a journey of the unknown and unanswered. We are seekers of the truth and the understanding of what happens to people after their earthly passing. We are, all of us, in a society that has become so focused on progress that we sometimes fail to realize that, as human beings, we have somehow left out our spirituality. I now truly believe that we are all spiritual beings having a human experience.

I will never defend what I believe in or what I do. If I were to do that, I would have to admit that there is something to defend, and I believe there isn't.

I believe that you don't have to have any degree to experience the paranormal or research the paranormal. The world that we can't explain—that of supernatural and paranormal events—doesn't ask for a certificate or diploma for you to gain admittance. There are those who have gifts bestowed on them—singing, dancing and artists—and the second sight of the paranormal is also delved out by someone greater than us. I'm one of the lucky ones who was born with this gift, and I'm here to share with you the experiences of me and my team. I believe communication with ghosts/spirits is possible only if we open our eyes and hearts to it.

Some names have been changed throughout to protect the privacy of the individuals. Such changes are denoted by an asterisk.

ACKNOWLEDGEMENTS

DENNIS: I wish to thank Bernadette Peck, the leader and founder of the Ghost Seekers of CNY, along with her fantastic team: David Peck, Leonard Bragg, Kathleen Durr, Ed Livingston, Marlene McQuade, Gari McQuade and Marlene Marrello. Also, a large thank-you to Whitney Tarella, commissioning editor extraordinaire, Ryan Finn, eagle-eyed project editor, and the rest of the staff at The History Press for giving these tales a home. Also, I'd like to give a large appreciation and love to my mother and father, Charlene Webster and Milton Lee Webster. Finally, thanks to my cousin, Evelyn Webster, for reviewing the first draft and giving me terrific feedback.

BERNADETTE: I wish to thank, first and foremost, my dedicated team. Also, my dad, Anthony Stolo, for his enlightenment on my journey. My mom, Phyllis Stolo, who after passing has assured me. My husband, Dave, who patiently supported me through my paranormal experiences. My children, Kristin Cook and David Peck Jr., whom I love with all my heart. My brother, Jim, for courageously coming in full to me after his untimely passing as validation of my belief. And, finally, to Dennis Webster, for believing that there is life after death and telling my stories with a heartfelt approach.

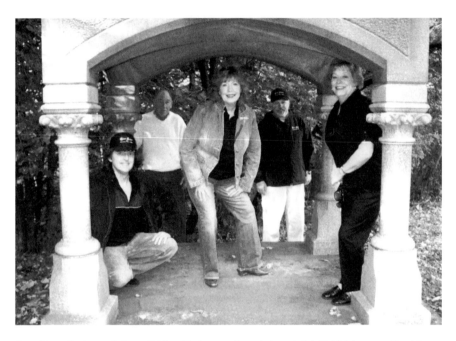

The Ghost Seekers of Central New York team (from left to right): Ed Livingston, David Peck, Bernadette Peck, Len Bragg and Kathleen Durr.

INTRODUCTION

WHAT IS GHOST SEEKING?

There are many out there who are curious and seek to obtain answers. Ghost seekers are those who delve into the haunts of our historic past and interact with the paranormal of the now. Like a moth driven to a flame, people who seek contact with the paranormal are compelled to the contact with ghosts. This work will highlight historic haunted locations in the Mohawk Valley, as well as explain the gear used in the field and the terminology employed by experienced ghost seekers. Most can't imagine that there is a decorum expected when interacting with the spirit world. This book is for those looking for the inside story of ghost seeking and to further their education of the historic Mohawk Valley. This book will profile historic locations through the hunts conducted by the Ghost Seekers of CNY.

THE STANLEY THEATER

Utica, New York, November 2008

The marquee in front of the Stanley Theater noted, "Players of Utica Presents Scrooge, December 12th," yet it wasn't a live actor show I was there for, but rather a performance of another kind—a performance of the spiritual, one on electronic magnetic field (EMF) recorders, digital tape recorders in the form of electronic voice phenomena (EVP), motion detectors and digital film. It was to be a theater of the ghost.

The Stanley Theater was opened on September 10, 1928, and is located in Utica, New York. It is one of the city's downtown landmarks. The architect, Thomas Lamb, designed the 2,945-seat theater with "Mexican Baroque" styling. The interior is a lavish display of gold leaf columns and staircases adorned with cherubs, lions and Indians. The staircases are wide and inviting, with the legendary "Grand Staircase" possibly designed to represent the grand staircase on the ocean liner *Titanic*. The elegant, brooding and rich interior is complemented by the jutting Art Deco marquee, inviting all lovers of entertainment into the Stanley Theater's artistic bosom. The Central New York Community Arts Council Inc. (CNYCAC) purchased the Stanley Theater in 1974 and has upgraded all facets of the operation, from electrical and safety systems and the new carpeting that replicates the original patterns to the plush, velvet-covered patron seats.

The Stanley Theater moved beyond being just a place to show movies when it started hosting live events with Munson-Williams-Proctor Institute,

Broadway Theater League, the Utica Symphony and the Mohawk Valley Ballet, all displaying world-class entertainers.

The Stanley Theater sits in the heart of downtown Utica, New York, a city that was incorporated in 1832 and has more than sixty thousand residents in the midst of the Mohawk Valley of Central New York. It's a marvel inside and out, and the CNYCAC granted permission to the Ghost Seekers of Central New York to conduct the first-ever spiritual investigation of the theater. The Stanley Theater has enthralled and entertained hundreds of thousands of Central New Yorkers and has hosted hundreds of world-class entertainers since its establishment, including a skinny boy who watched *Star Wars* for the first time for one dollar in the late 1970s. I was hoping that the Stanley Theater would be a hotbed of psychic and otherworldly activity, especially those spirits that so enjoyed the theater in this world that they wished to continue their theatrical pursuits in another.

The Stanley Theater has had a long reputation of being haunted, especially the legendary "ghost row," which is the last row straight from the stage, seats 101 through 113. Tales have been told of one haunted seat in this row that has never been sold, although this is an urban legend. The reason surmised for this being called "ghost row" comes from the olden days, when men greased their hair back. They would then lean their heads against the wallpaper, thus leaving a smeared head print. This remnant would look like ghosts sitting across the back aisle. In the current remodel, a piece of Plexiglas has been set in place so this will not be repeated. This, along with the fact that there are thirteen seats in this row, has fueled the stories. The Ghost Seekers of CNY informed me that tales and legends can be sometimes cause fact to lie behind the myth. We were about to find out if the Stanley Theater was truly haunted.

The late afternoon of November 15 was one during which torrential rain and wind tore across the Mohawk Valley in the midst of a balmy fifty-seven degrees, making darkness hit Utica at 4:30 p.m.. The wake of the storm left a gibbous moon lighting up the sky as slivers of wispy clouds sliced across the lunar glow, enhanced by mist and fog rising up, creating a foreshadow of things to come. I arrived at the Stanley Theater at 9:00 p.m., and the Ghost Seekers of CNY members were setting up their equipment. I was greeted by the night watchman, Bob, a tattoo-covered man with a sweet smile and an accommodating attitude. He allowed Bernadette and the rest of the team to come and go and set up their equipment with no interference. The other members of the team, Len, Ed, Kathy, David and a special observer, Linda*, greeted me with

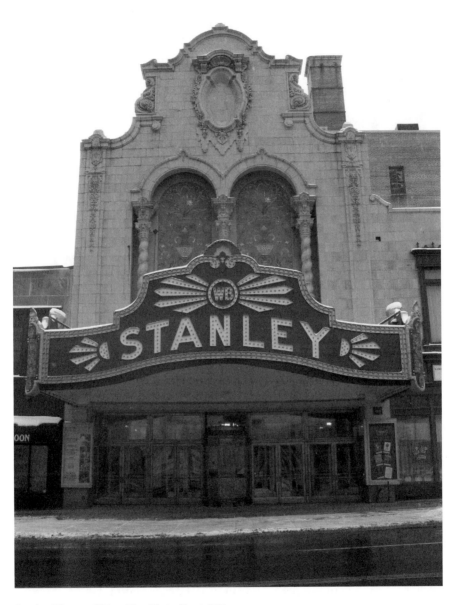

Stanley Theater, Utica, New York. *Dennis Webster.*

An orb on the northern staircase of the Stanley Theater.

a smile. Bernadette stated that the geomagnetic field was strong, which could mean a positive hunt.

The Ghost Seekers of Central New York had arrived armed to scour the historic landmark for spirits, ready to perform in the Mexican Baroque theater that had never once been investigated for ghosts since its opening in 1928. The team members were wearing identical khaki vests with a multitude of pockets filled with flashlights, recording devices, batteries and hand-held thermal guns. I walked in as newlyweds were posing for pictures on the grand staircase with their wedding party. I wondered what they thought as cameras were being set up and wires strung?

Bernadette informed me that when the ghost seekers were in the theater earlier to do a walkthrough, they videotaped the entire event. Upon reviewing the footage, they found that they had captured an image of a shadowy figure at the bottom of the stairs that leads to the basement ladies' room. They were unable to debunk or re-create this shadow figure. I had a feeling that this would be a hot spot and that I was soon to get the thrill of a lifetime in the same area.

While the team went about setting up the equipment with military-like precision, I wandered a little bit with my mind open and my heart ready to embrace anything that happened to come my way. I went up to the balcony area of seats and watched Bernadette and Kathy walking across the stage, talking and pointing up to the area where I was standing. I was by exit no. 5 when I felt a cool chill hit me across the back of my neck that made the hairs rise on my arms. I turned, but there was nothing there. I felt all over for any kind of air blowing, yet there was nothing. I took a step and the chill was gone, only to return when I went back through the same spot. When I met Bernadette downstairs, I mentioned my feelings, and she marveled that she had the same feeling toward that upper-right corner—she was pointing at something when I had my experience.

Dave, Ed, Len, Kathy, Bernadette, Linda and I all held hands in a circle for the team's opening prayer. I felt comfortable and safe as Bernadette recited a prayer:

> *Holy Michael the Archangel, defend us in battle. Be our safeguard against the wickedness and snares of the devil, and do thou prince of the heavenly host, by the power of God, cast into hell Satan and all the evil spirits who wander the world seeking the ruin of souls. Amen.*

Ed finished her sentiments, asking only friendly spirits to reveal themselves and assuring them that we meant no harm. I felt that this was a great way to begin my first-ever ghost investigation. Many years earlier, I had been on a ghost hunt with another passionate group of spiritual hunters, yet it had been nothing like being with the Ghost Seekers of CNY. This was scientific, technical, serious and thrilling. They had me, the amateur, in their midst, yet they were steadfast and had their game faces on. There would be no tomfoolery.

The amount of equipment set up was staggering. The digital cameras were set up at the bottom of the grand staircase shooting upward, one in each aisle filming the stage, one in the basement ladies' room and a wireless camera on the stage shooting up to the right corner where I had felt a chill and where Bernadette's senses had spiked. Wiring from each snaked into the lobby, where a large split-screen monitor showed the view while a hard drive burned the images onto a DVD. I tried to make myself useful by taping the wiring down on the floor so that we wouldn't trip and knock a camera to the floor in the dark. Each ghost seeker carried a flashlight, extra batteries, a two-way radio tuned to channel 7, a hand-held electromagnetic indicator, a

The Ghost Seekers team at the Stanley Theater, with an orb above the staircase.

hand-held thermal gun and a small digital recording device. No wonder they had the multiple-pocket vests on—they were going on a ghost safari.

Before we split up into groups, Len and Dave were trying to fix the camera on the stage. The black-and-white monitor's picture was flickering and acting up, giving me an impression that something was there playing around. We were soon to find out what it was.

The team was divided into two groups: Bernadette, David and Kathy went down to the men's room in the basement, while I went with Len, Linda and Ed into the ladies' room in the basement. Len pointed out the spot where the team had videotaped the ghost at the bottom of the landing. We walked around until Len decided to set his camera up in the lavish waiting room that was straight across from the toilets.

It was 10:22 p.m. We sat in the plush chairs while Len set everything up. He took out a small flashlight and loosened the end cap until the batteries were disconnected. He tried the on/off button, verifying that the flashlight would not illuminate with human touch. He set it on the table next to the camera and the gauss EMF (electromagnetic field) detector. Ed killed the lights, and we sat in complete darkness. Len had his hand-held recording

device. He and Ed started out by letting the spirits know that we meant them no harm and that we were there in friendship and mutual understanding. He then began asking questions of the spirits. I sat in silence throughout all of the questions, trying not to be an interference but rather an active watcher and listener. I kept getting the feeling that something was approaching from the other room. I looked over my shoulder and saw nothing. Then, out of the corner of my eye, I saw a light twitch, a beam bend that I thought was a hallucination until Linda exclaimed that she'd seen the light flicker and move. Between the video with the ghost at the bottom of the stairs and this, I knew we were in a paranormal hangout.

The questioning went on for at least half an hour, with Ed apologizing for us men being adjacent to the ladies' room, assuring the spirits that we were gentlemen. Len asked that if there were a spirit in the room, would it please light up the flashlight. The flashlight slowly flickered and then came to full beam. My jaw dropped as I felt a chill down my spine, along with every hair on my arms raising and bringing goose bumps along for the spiritual ride. Ed thanked the spirit and asked it to shut off the flashlight if it was a female. The flashlight shut off. After a few minutes of amazed and stunned silence, Ed thanked the ghost and requested that it please turn the light back on. Again, the flashlight gained brilliance as it came to full power until a steady beam pierced the blackness of the ladies' waiting room. All I could do was breathe and listen to the singular dripping from the sink in the other room.

The EMF meter spiked, causing a quick burst of excitement, until Len proved that it was a false reading being caused by the walkie-talkies.

We wrapped up the proceedings and went upstairs, where we met Bernadette, Kathy and Dave. Even the levelheaded and cool Len was excited about the flashlight, and the always optimistic Ed was chattering and gesturing about our success with connecting to the other side. The term I was given for what had happened was an "intelligent haunting," which means that it was an independent ghost that moves and manipulates of its own free will, unlike a "residual haunting," which is a ghost that repeats the same maneuvers over and over, as if it were a spiritual rerun.

After the excitement, we took a quick coffee break and then went down to the men's room in the basement, hoping to repeat what had happened in the ladies' room. Len repeated the flashlight setup, and we sat on the floor. Ed asked the men to outdo the ladies. We could hear noise to the left, but the team quickly determined that the noise was coming from a restaurant adjacent to the Stanley that was open late, for we could hear a smidgen of talking and the clinking of plates. I didn't get the same feeling in the men's

room that I did in the ladies' room. The flashlight never came on, nor did any other phenomena occur.

It was about midnight when we went up into the projection booth to set up the equipment. I was enthralled by the old projectors, and everyone respected the majestic theater by not touching anything other than the stairs and ladders. It was quite an honor to be in a place where so few have treaded. The rest of us went back down to the balcony to try to get some electronic voice phenomena, while Len stayed in the projection room and Ed stayed in the back with his digital camera.

The group sat quietly while many questions were asked of the spirits by Bernadette and Kathy. Dave was trolling around with the digital thermometer, scanning for cold spots. After a while, Ed came down and was happy with the large amount of orbs he was getting in most of his shots. He showed me an image taken from the balcony of the Stanley stage that was loaded with orbs. He explained that all the photos would have to be carefully reviewed for false occurrences. Len returned to the group and mentioned a real spike in the EMF meter in the projection room.

It was 1:00 a.m., and the group members felt satisfied with the amount of video footage, digital recordings and digital photos they had taken. They explained to me as I was assisting in the breakdown of the equipment that they had a lot of homework to do. The team had to carefully go through everything, rule out anything that could be explained and seek anything unexplained. I knew that the flashlight incident would be strong proof of a haunting, but I'd have to wait for the Ghost Seekers of CNY to get back to me with the findings. They also had to conduct a "reveal" with the manager of the Stanley Theater during which they would give their opinions on whether the theater was indeed haunted. I have to say that it was a very exciting evening, and I can understand the draw the world of the ghost seekers.

ADDITIONAL OBSERVATIONS FROM BERNADETTE OF THE GHOST SEEKERS OF CENTRAL NEW YORK

The Ghost Seekers members filmed for more than four hours on five different cameras, took hundreds of photographs and recorded hours of information that needed to be debunked, reviewed and analyzed for any possible evidence of a haunting at the Stanley Theater. Everything is scrutinized, with only the best possible evidence put forth as proof. Anything that was deemed false

would be eliminated. In addition to my first-person account of the Stanley investigation, Bernadette provided me with her own personal account of incidents involving her, Kathy and other team members.

Exit 3 seemed to be a place everyone was drawn to, especially Bernadette and Kathy. They were drawn to the exit from up on the balcony. When they were up there, their equipment kept failing, and there was a large, visible orb that hung in the air and that was captured on their digital camera. It was as if it allowed itself to be photographed and then dispersed right in plain view.

Bernadette, Kathy and David were investigating the tunnels that snake below the theater when their K2 meter went crazy with wild readings while strange noises were heard, along with additional orbs. Everyone had a general feeling of discomfort. The group members kept hearing faint talking and whispers that they just couldn't hear clearly enough. Bernadette listened to the recordings later and heard a distinct EVP stating, "Where have they gone?"

The ladies' room was the hottest paranormal spot in the theater, given the earlier flashlight incident. While Bernadette meditated in the ladies' room, Kathy snapped pictures from many angles. All photography showed a hovering orb around Bernadette. The K2 meter was spiking high in the ladies' room when the orbs were making their appearances. The best evidence in the ladies' room was a distinct EVP that had responded to Kathy's question "Is there anyone here?" A distinct woman's voice is heard replying, "Laura." At this precise moment, an orb was captured on film going toward Bernadette and halting. When the group was leaving the ladies' room, Kathy had stated, "Ok, we better get going." Once again an EVP replied, with a "Hmmm."

At the end of the evening, when the group was cleaning up, a physical object was moved. The second-floor lobby bar was the location where the paranormal interacted with the solid of our dimension: Kathy witnessed coffee cups slide across the bar, moved by an unseen entity.

The conclusion of the Ghost Seekers of Central New York was that the Stanley Theater is indeed haunted.

HERKIMER COUNTY COURTHOUSE

Herkimer

I was thrilled with my next opportunity to conduct an investigation with the Ghost Seekers of Central New York. On the evening of January 8, 2011, we were to investigate the Herkimer County Courthouse. This three-story structure sits right across the street from the 1834 Herkimer County Jail. The jail had been investigated by the team previously and exhibited much paranormal activity, so I had a strong feeling that the spirits would traverse across the street.

The Herkimer County Courthouse is a wood and brick structure that, from a distance, resembles the appearance of a church, especially with the turret sticking high into the Mohawk Valley skyline. The current brick structure was rebuilt in 1873, with the earlier wooden structure that was built in 1834 having been burned down by inmates who had been housed there, according to online sources. The courthouse was listed on the National Register of Historic Places in 1972. The courthouse is rumored to have three hidden rooms that were sealed off in the renovation of 1939. The sheriff quickly squashed the other famous rumor—that there had been an underground tunnel connecting the courthouse to the jail across the street.

The courthouse has hosted some of the most famous criminal cases in the United States, with the top one being the Chester Gillette murder trial, in which he was convicted of killing Grace Brown. Gillette was put to death in the electric chair in 1908. I was told by David Peck, husband of Bernadette, that his grandmother, Lulu Youker, had been on the jury

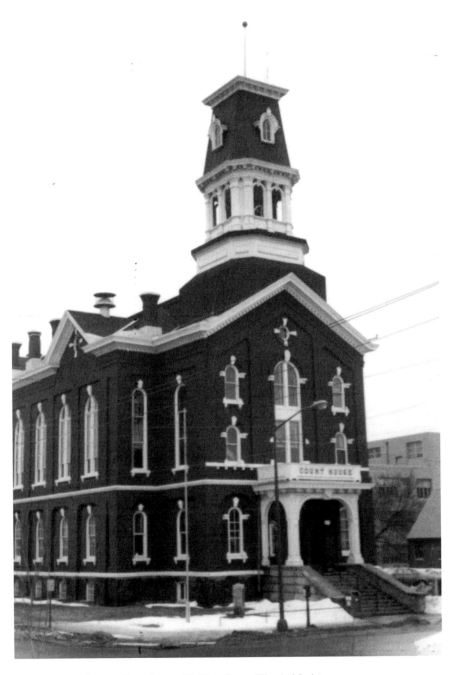

The Herkimer County Courthouse. *Herkimer County Historical Society.*

that had convicted Chester Gillette and sentenced him to the electric chair. This case was the inspiration for the novel *An American Tragedy*, which is ranked sixteenth on *Time* magazine's list of the one hundred best English-language novels from 1923 to 2005. This novel also led to the 1951 award-winning film *A Place in the Sun*.

The Herkimer County Courthouse had also been the location of the dramatic murder trial of Roxalana Druse Flowers, who was convicted of killing her husband by beating him to death. The theory is that Roxalana's daughter, Mary, had helped kill William Druse and then helped her mother chop him up and cook him in the oven. Roxalana had claimed that she was abused by her husband and that she acted alone in order to protect her daughter. The trial was one of great drama, and her guilty sentence sent her to the gallows to be hanged by the neck until dead. Roxalana was hanged on February 28, 1887. It was stated that people came from all around the Mohawk Valley to see the public hanging.

When Roxalana was hauled out to see the gallows, she shrieked with terror up to the point where she had to be dragged up the gallows, being held on each side by a burly lawman, muttering under her breath, "Poor Mary." It is said that the last words to come across her lips as they placed the hood over her head was, "By God, if I'm hung, I'll haunt you all in my nightclothes." It was said that the rope had not been knotted properly, so it took a while for her to strangle to death instead of the quick neck snap that usually led to an instant death. It's claimed that because of this long and painful death, hanging was replaced in New York State with the electric chair; no woman has been hanged as a capital punishment in New York State since.

With the tragic and horrific justice history of the Herkimer County Courthouse, I felt that there could be a great chance for spiritual interaction. It was a cold, crisp Saturday evening in the Mohawk Valley, when walking on the snow reminds one of crunching toast. The courthouse is nestled on the edge of downtown Herkimer, New York, a nice slice of Americana in the heart of the Mohawk Valley. I was so excited on the day of the investigation that I could hardly wait, looking at my wristwatch almost hourly until it was time to climb into my little mule on four wheels and drive out to Herkimer.

As soon as I pulled into the parking lot, I spied Len, who was trudging cords and cases into the side door of the courthouse. I exchanged pleasantries with Ed, whom everyone calls "Paranormal Ed," and Len as we entered into the courthouse, where I saw Bernadette, her husband Dave, her sister Marlene McQuade and her husband Gari. Marlene the

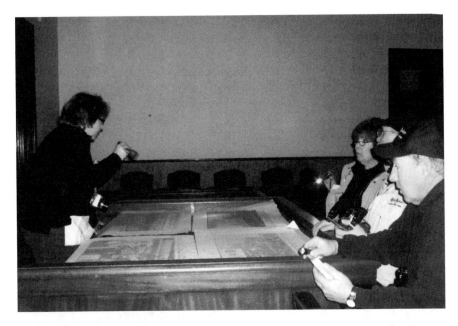

The Ghost Seekers team plying its trade in the courtroom at the Herkimer County Courthouse.

psychic was unable to make the investigation. I had my trusty pad and pen at hand, ready to write down all of the details as they unfolded, and one great tale happened immediately.

I had to follow Sheriff Chris Farber to the back meeting room so he could get a copy of my driver's license. With this being a public building, and one housing law enforcement, we were all mandated to give them a copy of our identities. I followed Sheriff Farber into this room and waited for him to copy my ID when I noticed that the door in and out of this room was very thick, old and made of metal. I asked the sheriff what was the deal with the door, and he told me that the room was originally a safe and that the thick door was used to secure a multitude of items. It was at this point that he told me of the corkboard incident. He and another sheriff's department employee were sitting at the round table and chairs when they both witnessed a tacked paper come away from the board, move down a foot and retack. An orderly ghost had moved the paper in the middle of the day, under police witness. I nodded my head and could tell the truth in his words. The sturdy lawman wasn't the type to make things up, and I marveled at his tale. He had also told Bernadette and the group that daily ghostly interactions had reached the point that they were treated by

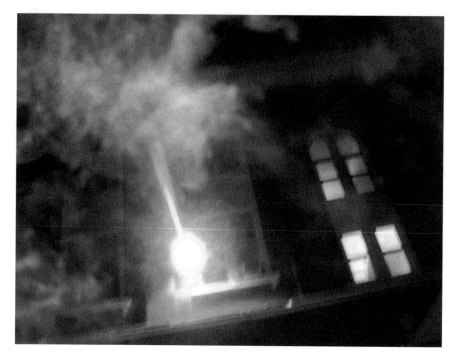

An exterior image of ectoplasm at the Herkimer County Courthouse.

the building staff with growing indifference. The sheriff stated that these spiritual encounters happened so much that they just accepted the extra ghost occupants as some of their own.

In addition to Chester Gillette and Roxalana Druse Flowers, the team was going to attempt to contact the spirit of Charles Thomas, who had been an attorney on the defense team of Chester Gillette. The current staff at the Herkimer County Courthouse have had run-ins with his walking entity. His office had been located in the basement of the structure, and current staff have seen a thin blonde man in period dress of Gillette's time. They followed this man, who was wearing a long dark coat and wingtip shoes. They have stated that he even turned and looked at them before vanishing into thin air. Another time, the undersheriff followed Charles's spirit into the bathroom, and he wasn't in there. This means that the ghost of Charles is an intelligent haunt—he's not an otherworldly spiritual imprint that keeps replaying (residual). Purposeful interaction with the living is considered an intelligent haunting. The staff had looked at an old photo of Charles and immediately recognized the long-dead attorney as the walking paranormal staff person.

Sheriff Farber locked the doors on his way out, leaving us alone to conduct the investigation. It was at this point that Bernadette led us on a walkthrough of the entire building to map out our strategy. The first floor acted as base camp, with everyone leaving their coats, coolers and large bins filled with all of the ghost-hunting accoutrements. One large case opened up like a fishing tackle box, with all the drawers filled with batteries, cords and a multitude of other technical equipment. By the time I had arrived, Len and the crew had already set up all the night-vision video cameras and were taping the extension cords to the floor. Once the place had all of the lights shut off, we couldn't be tripping and knocking over expensive gear.

Our walkthrough began at 6:15 p.m. by going up to the second floor, where just outside the courtroom Len had set up his four-way monitors. This digital screen had all four night-vision cameras streaming their pictures onto one monitor so that investigators can watch these static cameras live as they're filming. I was also shown a new piece of gear making its debut for the team: the PSB7 Spirit Box, which surfs sound frequencies and, when it hits on a paranormal voice, broadcasts it. I knew that the evening was going to have some excellent paranormal events because we were only in the courtroom a few minutes when the K2 meter started to move, indicating a possible entity presence. We went on the walkthrough up to the third floor, and as soon as we got to the top of the stairs, Bernadette looked to her left down the long and dark hallway and spied a shadow person peering around the corner. We walked down the hall, and the entity disappeared. There was a locked door that led to the turret, but we were not allowed to proceed up there for safety reasons. I stood and looked at the door, wondering what could be up there that we wouldn't be able to see.

It was at this point of the walkthrough that we went all the way down to the basement and walked through the cobblestone-walled rooms that housed storage, including a room that held the original pews and rails from the courthouse. These were never thrown out upon the renovation of 1939 and had an eerie calm. We then walked through an underground passageway that led to the old building next door. We were all looking around the basement when we came upon an old iron spiral staircase that was painted a deep green color. The ornate décor of the staircase was a marvel, so we followed it up; right away the K2 started to spike. This continued all the way up, and when we walked off the staircase, it ended. David and I returned later to set up a digital video camera that had only

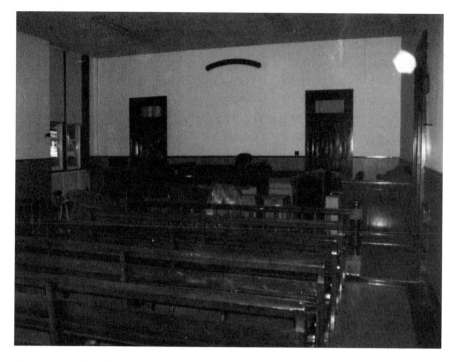

A courtroom orb and ectoplasm noose inside the courtroom of the Herkimer County Courthouse. *Dennis Webster.*

one hour of battery life. It was dead silence in that building, and we knew that there would be no form of sound interference from the building next door. The walkthrough had a lot of preliminary activity, and the full-blown investigation had yet to begin.

Before we started the official investigation, I went outside with Bernadette, Marlene and Ed. We were standing in the parking lot admiring the outside beauty of the courthouse and lamenting our denied access to the turret, but we understood the safety reasons. Ed was taking some exterior pictures of the building and showing them to me on the digital viewfinder when he snapped something that gave me a chill: a full-blown ectoplasmic entity hovering by the brick building. He had just taken another picture of the same location mere seconds earlier and captured nothing, and then this eerie presence. We all marveled at the ectoplasm caught by Paranormal Ed and went back inside to share the photograph with the rest of the team.

The last thing we did before we shut off the lights was to gather in a circle to conduct the pre-investigation prayer of protection and respect.

I took my hat off as a sign of respect to God and the spirits. The prayer made me feel safe and secure as we unlocked our hands and hit all of the light switches, which sent us into complete darkness. It was 8:15 p.m. when we began the ghost hunt.

We headed up to the second-floor courthouse. Bernadette decided that the entire group would stay together throughout the hunt and not split into teams, which is the usual investigative methodology. The courtroom has old wooden pews, and some investigators sat in them while I went to the spot where the court stenographer would sit and placed myself in his chair. Bernadette started an electronic voice phenomenon (EVP) session. We all sat quietly while she asked questions about Roxalana, Chester and Charles. The Spirit Box was on during this, whizzed through frequencies and was transmitting a lot of squeals and noises that didn't sound like discernable voices. I just sat quietly, trying to write on my legal pad in complete darkness. I had to capture the moments as they occurred even if my writing was all over the paper. It was at this point that a few people claimed that the air was getting much colder. Bernadette had used her digital thermometer to set a baseline temperature in the courtroom at sixty-five degrees. She took the device back out and was getting the same, yet in some spots it was a plummeting fifty-five degrees. The theory is that ghosts use energy and power to materialize, and this can cause cold spots to occur where they're attempting the return to the land of the living.

After half an hour, we all decided to move on to the judge's chambers. It was at this point that I got up from my chair and immediately smelled flowers or a strong perfume. It was to my right, though nobody was there. When I walked through this spot coming in, there was no scent at all. Ed, who was sitting in the judge's chair in the courtroom, confirmed the flower smell. Scents can be associated with a haunting and paranormal interactions.

We all stayed in the judge's chambers for a while, with no real spiritual interactions to speak of, although EVPs tend to be found after the investigation since spirits tend to talk on a frequency that is not one the human ear can decipher. It was at this point that Bernadette made the decision to take the entire team down into the basement. It was much scarier in the darkness. Bernadette has a sixth sense when it comes to the spiritual world. She's been doing ghost seeking for a very long time and has more than a good knack for acquiring evidence. It was in the basement where she was drawn to the old storage room that housed the old courtroom chairs and railings. These antiques were stacked up in a pile and covered with an inch of dust. We all sat on the floor, with Len

setting up the infrared static camera. Dave took out a small flashlight and turned the end cap so that no power was getting to the bulb. When the group started the EVP session, the K2 meter started to flicker from yellow to green and then to red, which indicated that there was a spirit in our presence. I had this meter when we walked in, and I did a sweep before we sat on the floor; there was zero electromagnetism interference. There was no electricity in this room, nothing to cause a false reading on the K2.

Marlene, Dave and Bernadette sat on the floor across from where I was, while Len was standing behind me running the camera. The others were outside the room in the hallway. I could faintly hear their talking and walking. It was at this point when the paranormal veil opened up, and the most extraordinary paranormal interaction occurred. Bernadette asked, "If there is a spirit in the room, can you turn on this flashlight?" There was a powerful and immediate response. It was at this point that the flashlight came on strong. The energy from the ghost had powered up the flashlight. Bernadette and Marlene took turns asking the entity if it were Roxalana, Charles or Chester, although it did not respond. Dave chimed in, "Is that you, Grandma Youker?" The flashlight came on right away and flickered. I was stunned. The silence from everyone was in the emotional response from Dave. He asked again for confirmation. "Is that you, Grandma Youker?" Again the flashlight came on. Dave Peck is one of the most rugged men you would ever meet. His firm handshake and hearty voice reminds one of a tough American who pulled himself up by his bootstraps and took on the world. I was moved by his voice cracking and shaking as he interacted with the spirit of his beloved grandmother.

The silence was broken by a visitor to the room: Sheriff Douglas Barnes had stopped by to see how the group was making out. He came in the room and stood with Len behind the camera. Bernadette went back to the questioning, and it seemed for a minute that Grandma Lulu Youker had been chased off, but the flashlight came back on and she started interacting with the group again. I was amazed at this interaction, that the love of a grandmother could pierce the mortal realm and send a message to her dear grandson. It was one of the most emotional interactions I have ever witnessed. It made my skin stand up with goose bumps and even moved Sheriff Barnes, who I'm sure was as steely as all lawmen.

We moved out of the room, and Gari set up the camera to capture the steps up to the first floor, where the ghost of Charles had been witnessed walking to his basement office. The interaction in the storage room spilled out onto the steps, with strong K2 readings and a continuation of the

flashlight coming on and off. Bernadette mentioned the paranormal veil being opened, and I agreed with her assessment, for the interactions picked up strength and intensity. The strong ghost activity continued on the first floor, but the climax would happen upon our return to the courthouse. It was now approaching midnight, so Bernadette wanted to take everyone back up to the courtroom for our last session of the investigation.

The entire group took their places in the courtroom, but this time there was no Spirit Box running. I decided to sit on the floor with my back to the wall so I could see the entire room and the doorway. It only took a few moments of Bernadette and Marlene asking questions before the flashlight came on. This time, the illumination was a different strength, duration and color. The light had a faint orange tint and stayed on for a few minutes at a time. Grandma Youker had made the light a more yellow color that burned bright and went out after several seconds. Bernadette felt that this was Roxalana in the courtroom and received confirmation when the long-dead woman turned on the flashlight to specific requests. The entire team of ghost seekers was impressed with this interaction, for they had never seen a flashlight be kept on for this length by a spirit. Roxalana wanted us to know that she was there. She wanted to send us a message. The Spirit Box was finally turned on, and we did receive a strong voice from the other side. Upon Bernadette asking how many spirits were in the room with us, a ghostly voice came across the Spirit Box, very loud and clear: "Six." It was at this point that I witnessed a streak, or what I would describe as a spiritual smear, that came across the doorway, about two feet off the ground. Unfortunately, nobody else witnessed this, and it was not in the view of the digital video camera. I can't explain it away as any kind of reflection since everyone was sitting perfectly still and the shades were drawn.

It was well past midnight, and Bernadette made the decision to end the investigation and clean up the gear. I was full of adrenaline, for it was another successful outing with the seekers. I admired the ethical approach of the team and the professionalism and respect they give the spiritual world. We all chipped in with carrying gear to Len's vehicle, and the last thing we did was hold hands and pray for a peaceful exit. The last thing any of us wanted is a negative entity attaching itself to our physical bodies like a paranormal leech. We exited the building, and the cold, crisp January evening picked me up as I got into my car and drove off, pausing one last time to look at the beauty and grandeur of the Herkimer County Courthouse. I will never forget David Peck's interaction with Grandma Youker.

ADDITIONAL OBSERVATIONS FROM BERNADETTE OF THE GHOST SEEKERS OF CENTRAL NEW YORK

Post-investigation note: I spoke with Bernadette a week after the investigation, and she told me about a possible piece of paranormal evidence. On Dave's hunch, we placed a digital video camera at the top of the wrought-iron spiral staircase in the building next door. Now Dave had explained to me that the battery to the camera would only give him one hour of recording time. When Dave and Bernadette went back and analyzed the footage, they watched for almost the full hour with nothing to report, but with a minute left on camera something happened. Now I had gone into this building and climbed this spiral staircase, and there was no way you could hear anything from the ghost seekers in the building next door. Remember, the K2 meter had lit up on the stairs every time I ascended and descended them. Well, the ghostly sound of footsteps was captured on the last minute of the video camera. There was absolutely nobody in this building. It was on complete lockdown by the sheriff's department. Sheriff Farber has heard this evidence and thinks that it was heat pipes within the building. The Ghost Seekers members have decided to take Sheriff Farber's interpretation of rattling, so this piece of evidence has been debunked.

Regardless of the heat pipes on the stairs, there were a lot of interesting pieces of evidence, including a couple fantastic EVPs. When Bernadette was conducting this session in the courtroom, a distinct name, "Ward," was recorded. This was the last name of the judge in the Chester Gillette trial. Also, when Bernadette got up to leave the courtroom, she was recorded as saying that she was cold when a ghostly voice said clearly, "go back." Also, a bunch of orb activity was caught on the digital video cameras, including one that came down the hall, turned a corner and headed up the stairs. The cameras had been drained of power in the courtroom, and there were many spikes on the K2. When Grandma Youker was turning on the flashlight in the basement, an orb was spotted sitting on one of the antique courtroom chairs. A spirit tapping on the stairs was also picked up on audio. The two spookiest pieces of evidence were when Paranormal Ed, who was wearing a pair of night-vision goggles, spotted an apparition of a shadow person on the second floor and when Bernadette witnessed a white apparition coming through the main entrance of the courtroom and going up the stairs to the courtroom. The sheer amount of outstanding paranormal evidence at the Herkimer County Courthouse must make it one of the spookiest places in America.

OLD STONE FORT

Schoharie

I was excited to hit the road again with my friends from the Ghost Seekers of Central New York, as we were to be investigating the Old Stone Fort in Schoharie, New York. The Old Stone Fort was built as a church in 1772 and has many of the original parishioners' names chiseled into the stones. In 1777, with the onset of the Revolutionary War, the fort had a stockade fence built around it to enclose the structure in case of attack by the British. On October 17, 1780, the fort was attacked by a group of Loyalists and Indians under the command of Sir John Johnson and Mohawk captain Joseph Brant. This attack left a cannonball hole in the rear of the building that is still visible today. After the war, the stockade fencing was removed, and the fort again became a church for the community. This continued until 1844, when it was sold to New York State in 1857 for the pricey sum of $800, whereupon it was used as an armory until 1873. Then it was turned into a place for historical usage. The campus of the Old Stone Fort now includes a museum, a Greek Revival–style house, a Dutch barn and thousands of warfare and peacetime artifacts on exhibit to the public.

The night of the investigation was filled with weather drama. It was the night of February 5, 2011, and we had a mix of sleet, snow, rain, lightning, thunder, wind and hail. This onslaught of weather was sure to create a paranormal heightening. My dangerous drive took me down tree-lined winding roads in almost complete darkness, with my little car sliding all over the place and the drive time double what it would have

been on a good weather evening. I had a really good feeling about this investigation, and these feelings would be validated as soon as the official ghost hunt began.

The Ghost Seekers members would be using two psychics for the first time at the Old Stone Fort. Irene Rakowski Crewell and Coryelle Kramer are well known and highly regarded psychics. Bernadette Peck, who leads the Ghost Seekers, had met these two ladies previously to screen them and see if they would be able to work with the team. They more than passed the test, so Bernadette invited them to work on the Old Stone Fort case. Upon arriving at the fort, I met Irene outside and received a warm hug. After all, we had been sixth-grade classmates a long time ago. It's strange how life brought us back around to this investigation. Bernadette had her team there: David Peck, Ed Livingston, Len Bragg, Gari McQuade and Marlene McQuade.

The Old Stone Fort is a beautiful building that looks as immaculate as when it was first built. Standing out front, I noticed gravestones on both sides of the building that seemed eerie under the winter lightning. The snow had a thick layer of ice on it, which reflected each lightning bolt across the headstones, illuminating the names of the dead. I followed the group into the fort and stepped through a large wooden door with an unusual latch. The gear was already set up, so we went into the far backroom, where the four-way monitor was set up.

It was in this backroom where I met Carle Kopecky, the museum director and business manager of the Old Stone Fort, who came across as pleasant, with a sly smile and pleasing sideburns of gray. After exchanging pleasantries, it was Carle who had the best line: "It was a dark and stormy night." The moment lightened the mood up, until I noticed that Irene had sat down and was saying that she didn't feel well and was going to throw up. She had no idea that this backroom that serves as Carle's office is the place of apparition sightings. Everyone was all sitting, standing and chatting in this backroom as the excitement was building. I had a little knot in my stomach that I always get when something exciting is about to happen.

Bernadette decided to begin the night by doing a sweep of the entire structure to determine the location of static video cameras that would attempt to capture the evidence. I was enthralled by the beauty of the items on display on the first floor. Hanging and in display cases were muskets, bayonets, cannonballs, tools and more Revolutionary-era items. The concrete floor of the fort felt cold through my sneakers. Bernadette gathered the entire team, we held hands and she led us in a prayer of protection and

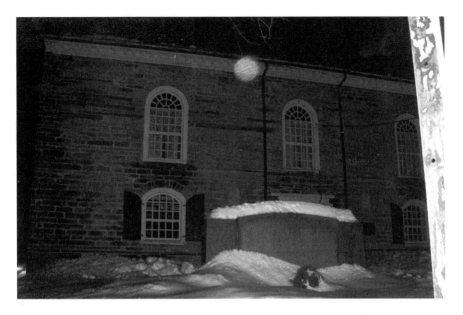

Old Stone Fort, with a visible orb.

respect to the entities with which we were about to interact. I admire her leadership and the professionalism of the entire ghost-seeking team. These are angels in another dimension, sometimes confused, sometimes purposeful, but always treated with the utmost respect by Bernadette and her team.

The first place we went on to sweep was the bell tower, a five-level wooden structure that was attached to the fort. Originally, when the fort was a church, it housed the bell, but then it later served as a military lookout. Up on the second level was the entrance to the second floor of the church. At that time, farmers, escaped slaves and other poor citizens had to use this entrance and would watch the church services from up there. The rich citizens of the area were able to use the main front entrance and had first-level seating. I had recently purchased a gauss meter (K2 meter) to measure the electromagnetism of any investigations. I was getting a baseline that showed no activity.

The stairwell was steep and made of very old wood, yet it seemed extremely rugged as we climbed upward. There was graffiti all over the place that was very old, including a carving of "Edwin Dietz 1887" on the side of the staircase. It was at the turn of the staircase of the third floor where Coryelle picked up the strong feeling of a male ghost that would stand and

look out over his young lover, who had died and was buried in the cemetery below. A romance cut short, now a spirit spending eternity gazing at his lover's burial site. Bernadette placed an "X" with black tape to mark the location to set up the video camera.

The sweep continued on the first floor of the museum with the corner of the room with a rocking horse and then toward the pulpit of Reverend Johannes Schuyler, who was born in 1710 and died in 1778 and was buried right beneath the pulpit in the fort museum. We went up to the second floor on the sweep, and I was curious as to why the many rows of display cases were covered with sheets. Carle explained that the artifacts were light sensitive—not only are they covered most of the time, but flash photography was also not allowed. The second floor had a vast collection of incredible items like military uniforms, a sheep-powered machine, eyeglasses, children's toys, a disturbing doll with a demonic stare, church pews and a pipe organ. The one item that drew in me and the others was the glass headstone from a four-year-old girl named Daisy Schoolcraft. Daisy had lived from 1883 to 1887 and had this thick glass headstone that someone had vandalized. A cruel person had pushed it over and broken it, so the pieces were put together, placed it in a frame and given to the fort. I was especially moved by the family lamentation on the headstone:

> *In memory of*
> *Daisy Schoolcraft*
> *Free sin could blight or sorrow fade.*
> *Death came with friendly care,*
> *The opening bud to heaven conveyed,*
> *And bade it blossom there.*
> *Born March 25th 1883*
> *Died September 17th 1887*

I took off my hat and said a prayer on behalf of the little girl dead seventy-nine years before I was born.

It was in the sweep of the second floor when a physical interaction with the paranormal realm came to fruition. Over near the display case of a military uniform, it is said that the ghost of the long-deceased Simon Mix would be seen by staff and visitors. As we worked our way around the room, Irene walked by this display case and said, "Something just grabbed the hair on the back of my head." There was nobody there, but then the ghost of Mix did it a second time. We were all stunned watching this, and Bernadette

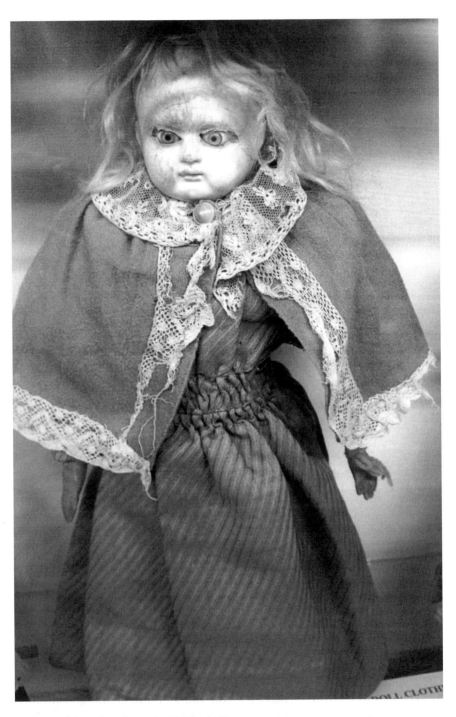

A demonic doll on display at the Old Stone Fort.

stepped forward and asked everyone to be quiet to see if Coryelle could experience anything similar. I was excited but kept myself composed. When Coryelle got to the same location, she reached back, touching her neck and saying, "Whoa! What was that?" It was obvious that the spirit had decided to interact with her, too, and had touched the back of her neck.

It was 10:00 p.m., and the lights were turned out and the investigation begun. Bernadette split everyone into two groups, with her, Marlene and Coryelle watching the four-way, while the other group started the investigation. This group included Paranormal Ed, Len, Dave, Irene and me. We started out on the first floor of the museum. The darkness among the artifacts and the luminescence of the outdoor lightning made for a ghost-hunting atmosphere you only read about in books. The thunder outside seemed to rouse the spirits, for we were getting hits in the K2 as soon as we approached the corner of the first floor where the rocking horse was located. Right away, Irene started to channel multiple spirits and said that she was getting the chills. It was at this point that Bernadette called us on the two-way radio, stating that there was a massive amount of orb activity around Irene. Dave and Len had their digital recorders as we were performing an EVP session.

It was at this time that all of us heard a thud over in the corner. Then Irene and Dave mentioned a cherry tobacco smell. I smelled nothing, and I was five feet away from them. It is theorized that ghosts will use all of the human senses to make their presence known, so the scent was an indication that we had a paranormal presence. Len placed his flashlight on the railing and asked the spirits to turn it on; they responded with a bright illumination. This interaction works by loosening the end cap, so that a human cannot possibly turn on the flashlight. The entity energy from the ghost will flow into the device and power it. The spirits will do this on command and from ghost seeker queries. It was at this point that I smelled the cherry tobacco. It was not a burning smell but rather a pleasant smell, like your grandfather's unlit pipe. Irene went from having the chills to overheating from the paranormal interaction with the spirits.

At 10:30 p.m., we went up to the second floor. Walking across the wooden floor made a lot of loud creaking, so we'd have to be perfectly still to perform the EVP session. Dave led us over to the church organ area of the second floor. We all settled down, placed the K2 meters and digital recorders next to the flashlight and began our session. The spirits were awakened and ready to engage since the thunder and lightning continued outside the fort. It was at this point when I had one of the most thrilling

and frightening ghostly interactions of my life. We were all sitting perfectly still, while Len, Ed, Dave and Irene were asking the spirits questions, when we heard distinct footsteps on the wooden floor. Bernadette and the rest of the group were still in the command center, and we were locked into the fort with nobody else in the darkness. I was sitting on the floor looking down the lengthy aisle between the display cases. The footsteps were loud and ghostly, walking right at us. It was a good dozen steps that got louder and louder and closer and closer. When the steps got near us, they halted, and the K2 meter lit up all the way to the red. The hair on my arms and the back of my neck stood up as if one of the lightning bolts had come through the walls and gave me a wake-up call. Then the flashlight illuminated. The cherry tobacco scent hit my nostrils. It was the ghost from the first floor following us around the fort. At the tail end of this interaction, a spirit touched Irene. She said that it was good energy, not malicious but rather curious. This spirit told Irene that her name was Martha. She was a very prim and proper ghost and explained through Irene that this was her place and that she wanted to know what we were doing there.

We all went back to the command center, and I sat and watched the four-way and was enthralled by the sheer number of orbs pulsing throughout the fort. I have been on enough of these investigations to tell the difference between a dust ball floating and a spirit energy pulsating with free will on a paranormal slalom trajectory. The entire group was abuzz with optimism from the high spiritual interactions. It was only an hour into the investigation, and the ghosts were roused and ready to play.

The next group went out, and it included Bernadette, Marlene, Gari, Coryelle and me. As the scribe on these ghost journeys, I'm able to hang on to the prime paranormal walkabouts. Of course, I have to be careful writing on my little yellow pad of paper. It's difficult to chronicle the investigation in an ink-black night. Bernadette decided to follow her spiritual instincts and led us right to the bell tower. Coryelle held an eagle feather in one hand that assists her in her channeling. The tower had a much greater creep factor in complete darkness. The wooden steps were well over one hundred years old: dusty, creaky and they gave off a paranormal ambience. I hung in the back of the group while Bernadette led the group up the stairs. I have been on multiple investigations with the Ghost Seekers of CNY, and Bernadette has the paranormal nose of a bloodhound. She can sense the spirits and always knows the exact places to halt to receive otherworldly interactions. I've seen her do this too many times for it to be a coincidence. Coryelle agreed with the stop on the second level of the bell tower and right away sensed the spirits

of two young people standing in the corner right behind Bernadette. The K2 meter lit up at this exact moment. Coryelle sensed that they were African American. The boy spoke to the psychic and said that his name was Elijah, while the girl spirit was more reserved and would not speak. Eventually, she revealed her name to be Celia. They explained that they were still hanging around because they wanted to see their grandmother.

As Bernadette led us farther up the bell tower, Coryelle picked up the spirits of several Native Americans, who right away asked her if she would sing their song. It was at this point that she held out the eagle feather, closed her eyes and sang the song in a language that I, for one, had never heard. It was a chilling moment of spiritual channeling that concluded with the Native American spirits telling her that they were thankful for her singing.

It was at this moment that something very frightening happened. Bernadette sensed a spirit ascending the stairs in a rapid manner that caused alarm by all. I was the person between Bernadette and this angry spirit, which Coryelle quickly spoke with and discovered that it was a pastor by the name of Thomas Morehouse. He was offended by the Native American singing in his house of worship. Bernadette spoke to the pastor, saying that we meant no harm or disrespect, so he moved on. Farther up the tower, we set the flashlight down on the steps. As Bernadette and Marlene asked questions to the spirits, it lit up. We finally came down out of the tower, and I, for one, was pleased with this departure. It was a dark and rather insidious place.

It was the peak of what turned out to be a fantastic investigation in a place that's highly haunted and filled to the brim with historic paranormal activity. I felt rather relieved yet saddened that the investigation had concluded because I had to say goodbye to my ghost-seeking friends. I'm honored to be included in their investigations and can hardly wait for the next time I get to delve into the paranormal darkness.

ADDITIONAL OBSERVATIONS FROM BERNADETTE OF THE GHOST SEEKERS OF CENTRAL NEW YORK

The Old Stone Fort had some really juicy tidbits of paranormal evidence. The sheer amount of orb activity picked up on the four-way was terrific, with a nice orb hovering over the Civil War exhibit. A distinct otherworldly growl and entity whispers were picked up during the electronic voice phenomenon (EVP) sessions. The infrared digital video camera up in the tower lost its

infrared capabilities for no reason and then came back on. David's post-investigation inspection found nothing wrong with the camera. Ghosts tend to interfere with electronics. When listening back to the EVP sessions, whenever the name of the ghost Chauncey is mentioned, the investigators repeatedly picked up the tobacco smell. He was making himself known via our nasal senses. Carle had reported that employees of the museum would always encounter footsteps between five and six o'clock in the afternoon, when the museum was closed and nobody else was in the building. Len went out early and set up a camera to try to catch these ghostly footsteps. Upon review by the ghost seekers, footsteps were recorded in the empty museum at 5:11 p.m., and then some electrical interference happened at 5:23 p.m. Finally, there were movements at 5:37 p.m. This validates the claims of the Old Stone Fort staff of paranormal happenings late in the afternoon. The best physical evidence was when Bernadette and Marlene were in the bathroom on the first floor. When the two of them were inside the bathroom and Bernadette was just closing the door, an entity grabbed hold of the handle and forcibly yanked the door out of Bernadette's hands, slamming it shut. Everyone else was in the back control room and the building was locked down, so nobody was in there to do this other than a ghost. This event was captured on a digital hand-held recorder.

FROM THE FILES OF THE GHOST SEEKERS OF CENTRAL NEW YORK

The stories of the rest of the locations in this tome were related to the author in first person by Bernadette Peck, founder and leader of this eclectic group of ghost seekers. I assure the reader that the following tales are 100 percent true and not for the faint of heart.

HULBERT HOUSE

Boonville—The Ghost Seekers of Central New York members conducted an investigation of the Hulbert House on multiple occasions in the winter and spring of 2006. The Hulbert House has always fascinated me, and having known its ghostly reputation for some time, I was thrilled at the opportunity to investigate this historic building. The Hulbert House is a majestic and historic hotel that was built in 1812 by Ephraim Owens. The Hulbert House is nestled in the beautiful village of Boonville, New York, right at the blue line of the grand Adirondack Mountains. In the nineteenth century, it was the most famous hotel between the Erie Canal and the St. Lawrence Seaway.

Boonville is adjacent to NYS Route 12, thirty-two miles north of Utica, New York, and forty-eight miles southeast of Watertown, New York, according to internet sources. In 1802, the first school was opened in this rugged land at the foothills of the Adirondack Mountains. Streetlights illuminated the village in 1989, telephones arrived in 1900 and electricity was provided to homes in 1904. It was and still is a place for the rugged

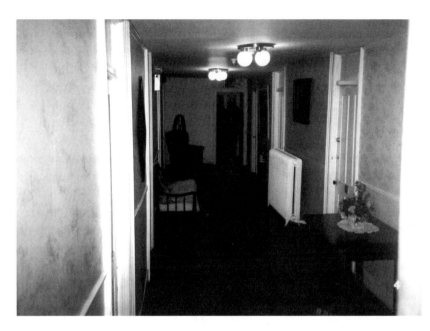

A shadow person in the doorway of the Hulbert House.

and hardy, for the wind chill and snowfall would match the toughest of northern locations.

The Hulbert House has had many famous guests in its history, including Franklin D. Roosevelt and General U.S. Grant.

Kathy, Len, David, Kathy, Ed and I first investigated in January 2006 in the dead of winter. It was a chilly day, with the crisp snow crunching under our boots and our breath fogging the air. The wind was blowing across the town toward the Adirondack Mountains and blanketing Boonville with a mask of cold. I was awed by the winter beauty at its deadliest; however, the warmth of the fireplace of the Hulbert House welcomed us as we came in from the dangerous elements, only to possibly face other hazards of the paranormal kind. Ghosts aren't bound by the elemental constraints we have in our mortal husks.

We shed our winter garments, with the thoughts of ghost seeking warming up our spirits and bodies. The hotel was closed to guests to accommodate us so that none of our evidence would be questionable. I took the team right up to investigate the third floor of the hotel and immediately captured numerous unearthly orbs floating from the hall right toward the camera. They also moved from left to right and right to left, as if they were playing

with us. There was no discernable pattern, and Len ruled out the orbs being produced by dust and human traffic in the hallway. There was no doubt in my mind that they were of a paranormal nature. The frequency of the ghostly orbs became lower and then stopped, as if the spirits were greeting us and welcoming the team to their home.

I felt that the best piece of evidence gathered by the ghost seekers on the third floor was an EVP of elaborate and echoing footsteps and other noises. I went back later on with the team, and we attempted to re-create the sounds but couldn't. I'm a firm believer in analyzing all evidence to ensure that the team has only pristine proof of the paranormal. We captured creepy, thundering footsteps going down the hall. We all kept very still, and no one was walking when the steps were recorded. Len had determined that nine distinct sounds were captured on the analogue recorder. I only hoped that the rest of Hulbert House would be as interesting as the third floor had been. How pleased I'd soon be as we headed down to the second floor.

The second floor produced the most stunning piece of evidence for myself and the ghost seekers. Photographs were being taken all over the second floor, and one 35mm image that I took revealed a shadowy figure standing in a doorway of the hall. Located at the far end of the second floor hallway was a ghost that appeared to be dressed in a Civil War uniform. I had researched and read that the Hulbert House had been a stopping point for soldiers during the Civil War, and perhaps this stranded tragic soul is still awaiting his final orders. Sometimes, a lingering spirit doesn't realize that it is already dead. This studious and loyal soldier needs his final orders to cross over to the next spiritual plane. We left and I was eager to return to the Hulbert House.

The Ghost Seekers of Central New York did return to the Hulbert House in June 2006, and this time I brought along our psychic adviser, Marlene Marrello. All of the usual gear was set up: infrared night-vision cameras, cassette recorders, digital recorders, 35mm and digital cameras and a four-camera video monitor. I felt that we'd find even better evidence of the paranormal than the last time we were there.

Marlene is always spot-on in her visions and connections to the other dimensional plane. Before she even went into the building, Marlene had the vision of many guns. She had no idea that the Hulbert House was used as a mustering point for Civil War soldiers, especially from the New York Ninety-seventh Infantry. As soon as she walked through the front door, she felt the presence of many ghosts. I knew that we were going to have a great session.

An ectoplasm entity in room 30 of the Hulbert House.

We immediately descended into the damp and musty basement, and Marlene, right away, got the feeling of a spirit named Danny, which explained, via Marlene, that he had used the corner in the basement to sleep off his drunkenness quite frequently, had died and now was there for eternity. My team always shows respect to the deceased, so we left Danny in peace and moved upstairs to the first floor.

Marlene and I walked the first floor; however, she didn't get a strong reaction. We didn't stay long, for Marlene was being pulled up to the second floor. We went up with trepidation. The first room we entered was no. 25, and immediately I felt an alarming negative energy. Marlene confirmed my feelings, and she began to feel uneasy and queasy. Marlene, Kathy and I calmed ourselves in order to open our quiet senses to any energy within this room. We were totally relaxed and almost asleep when there was a lull in these feelings of dread, and then we were startled as a great paranormal rush hit us and Marlene was quickly confronted by a tall, thin ghost in distress. Marlene said that she could see him and that the distressed man's spirit seemed confused and was wringing his hands. Marlene explained to the man that he was a ghost and to go into the light, that he didn't belong on this earthly plane. He told her that his name was Wayne just as he disappeared into the otherworldly paradise. Later on, when Marlene was shown the picture from the first time the ghost seekers were at the hotel, she said that it was Wayne in the picture.

Marlene and I proceeded to room 24, which also had some grim, negative energy similar to that in room 25, yet nothing appeared or manifested itself like Wayne. Sometimes, spirits can be shy, and we'll feel their presence as they drift away, whereas others are so curious or dreadful, seeking answers, that they'll punch through to our world in the quest for information, like

Wayne. When we went into room 28, Marlene picked up the name of the ghost haunting that location. The spirit revealed herself to be a timid and shy spirit named Tricia.

We moved on to the third floor, rumored to be formerly used as a brothel for VIPs during an earlier era of the hotel. Room 30 gave Marlene the impression of a violent and horrific death that had occurred there but could not pick anything else up. My senses could not hone in on the specific spirit, and our equipment failed to post hard evidence. Therefore, we had to assume that it was a residual feeling and not an intelligent haunting.

Upon exiting this room, we encountered in the hallway a peaceful yet confused spirit named Patricia. Marlene put her at ease and attempted cross-dimensional communication. Patricia explained to Marlene that she had been a maid and preferred to be called Tricia. She was in her thirties and wore a long dress. Marlene also got the feeling of womanly dread in the form of violence and unspeakable acts.

I and my team of ghost seekers determined without a doubt that the Hulbert House was absolutely 100 percent haunted. The next time you're in Boonville, New York, I suggest you stay at the Hulbert House. Just don't ask for room 25.

MORLEY GRISTMILL

Morley—I have always been fascinated by the stories of the haunting of the Morley Gristmill. After many investigations and a life in the paranormal, many places are known and discussed as otherworldly hot spots. The Morley Gristmill is one of those places that all ghost hunters would love to investigate. The members of Ghost Seekers of Central New York went to the Morley Gristmill to conduct an investigation in February 2002.

The Morley Gristmill is located in St. Lawrence County right on County Route 27 and is on the National Register of Historic Places, according to Martha Ellen. It was built in 1840 by Thomas Harison. The mill was built from stone acquired from Harison's quarry in Morley. Families in the surrounding area took the grist of wheat, barley, oats and corn to the gristmill, where four runs of millstones ground the grain into flour. The mill would run seven months per year, with the process continuing day and night until the gristmill was closed in 1935.

I was contacted by two filmmakers and students at Ithaca College Park School of Communication, Zack Minor and Ken Zickler, who wanted to do

Multiple orbs at the Morley Gristmill.

a film project on the group and its investigation procedures. I had met and worked with Zack and Ken before when they had been on an investigation with the Ghost Seekers of CNY in the city of Utica at a private residence. I cannot speak of what happened at the private residence, but I can tell you that working with two passionate filmmakers was more than enough to entice myself and the team into inviting them along on this trip to the Morley Heritage Gristmill.

My sister Marlene McQuade, David, Kathleen, Gari McQuade, the psychic Marlene Marrello and I met with Charlie Lashombe, who operated the Morley Gristmill. Charlie had invited us to come and do an investigation. He talked about the refurbishing of the building and that he couldn't keep workers around due to the tremendous amount of ghostly activity. The grievous spirits were driving away the contractors in an act of rebellion toward the mortal world in which they no longer had a presence. I was told of a carpenter named Jeff Sales*, who was painting on the ground floor all alone in the gristmill and kept hearing spooky footsteps up on the third floor. He left the building in a state of fear and panic and refused to return, leaving behind his expensive tools, brushes and other wares of his trade. When Charlie also heard this, he contacted me to investigate.

As soon as I walked into the gristmill with my team, I felt a heavy presence, which was confirmed by Marlene Marrello. She was receiving psychic visions and spoke with the spirit of a nine-year-old girl named Caroline. She picked up vibrations of young children and those of family life here in the mill from the early days of the operation. While we investigated, we heard the heavy, damnable sound of something being dragged across the second floor, but we did not see anything. The hair on the back of our necks stood up though!

The photographs from the Morley Gristmill showed an abundance of orbs and lots of mist. The team experienced alarmingly wrathful-sounding footsteps and the sounds of something being dragged across the wooden floor. This was not an EVP captured on a recorder but rather was experienced with our own personal hearing. Based on the evidence collected, my team and I concluded that the gristmill was an ominous, haunted place.

MARY CONNOR RESIDENCE

Utica—In 2001, I received a phone call from a distraught Mary Connor*, asking me and my team of ghost seekers to come to her home and investigate the possible negative and horrific paranormal activity that she was experiencing in her one-hundred-year-old Utica home. Utica has many beautiful century-old homes that were handcrafted by Italian, Polish and German immigrants. The city structures feature flavors, styles and ambience from throughout the world. Many of these old homes host the spirits of their creators, their descendants and other lovers of hearth and home. Mary's homestead was no exception.

Mary was frightened to the point of delirium. I have to hide her name in this telling, for she was worried about neighbors' reaction to a haunted house filled with hideous demons being right next door. I always maintain the highest level of confidentiality when it comes to investigations, especially in private homes.

I had a lengthy conversation with Mary explaining what could happen if she invited the members of our group into her home. We are not demonologists and tend to seek out only friendly spirits, but many hauntings have an appalling malevolence to them, an evil that neither I nor my team care to confront. In some cases, a ghost hunter can disturb the evil realm and make matters unnerving and traumatic for the homeowner. If we did this, even with innocent intentions, Mary's home could be deemed worthless to her and could force her to move to a new residence. This

The Ghost Seekers team entering the private residence of Mary Connor*.

investigation had to be taken very seriously and discussed in length before I'd allow my team to enter Mary's home. It's one thing to disturb the spirits in a museum or military fort. It's another issue entirely to disturb someone's home sweet home.

Mary let us know that she had resided in the home for the past twenty years and never had peace or rest due to a litany of hair-raising and horrendous spiritual activity that she felt transcended over to bad luck in her personal life. She told me that her mental and physical deterioration was consistently undiagnosed by doctors, and she felt in her heart that the negativity by the ghosts and spirits in her home was the root cause. She felt that the negativity, vileness and bad luck were transferring over to her two children. With nowhere else to turn, Mary contacted Ghost Seekers looking for help and assurance. This kind of request must never be ignored, for the paranormal offers mysteries we can only begin to understand. I would never underestimate the power from the other side. We would do what we could to help Mary.

Taking Ken and Zack along with us once again, my team of Marlene McQuade, Gari McQuade, Kathy, Kristen, Marlene Marrello and I entered the residence. We could feel the gloomy, devilish presence. The air felt heavy and thick to the lungs. The oppressive feeling was not something we normally felt in our investigations. We all looked at one another, for we all

had that feeling at the same time. I prayed that we could make a difference, yet we had to maintain our professional demeanor. I knew that the protocol of ghost-seeking decorum would be tested before our night was through.

I was immediately drawn to the second floor, so I went right up there, where I thought I'd seen something move. It was swift. When I walked onto the second floor, I felt sick and weak and became nauseous. I wasn't the only member of the team who was affected by the unhappy, malignant spirits. Team member Kathy was walking into the kitchen to get a cup of coffee and was pushed from behind by an unseen, spiteful spirit. Kristen went down into the basement and had such a strong feeling of unease, of being unwelcome, that she had to get out of the basement and out of the house. We encountered multiple cold spots in every nook and cranny of the house. These cold spots can be indications of paranormal activity.

The Ghost Seekers team normally steers clear of demonology and evil, angry, obscene spirits; however, we felt compelled to stay and assist Mary. One thing that caught my attention was that Mary had a shrine to the saints in her home that she prayed to, as well as lit candles, in hopes of repelling the evil spirits. Seeing this shrine made my spirit stronger. I was determined in what we were doing. It was obvious that we were dealing with a religious woman desperate for assistance. Mary told us that she'd had priests in her home to bless it on several occasions, with no luck at even dulling the hauntings and malicious movements of the ghosts. Marlene, who is a gifted medium and not afraid to take on demons, tried twice to sweep the negative spirits from the residence, but with no luck; instead, she encountered instead a malevolent male spirit that stood his ground and refused to leave.

Later, after the investigation, Mary told Marlene and me that she had sold the home and moved out. Her spirit had become broken by the constant barrage of otherworldly harassers. Kathy and I conducted a background search for information on the residence and discovered people moving out of the home every seven years since being built until Mary, who stayed for two decades of poisonous spiritual harassment. I'm pleased to say that since Mary has moved, she's been doing very well, with no more spiritual harassments. Sometimes, people can be a negative conduit to the spirit world and can be harassed by ghosts no matter where they plant their family roots. Luckily, Mary was not one of these. The entire ghost-seeking team was thrilled that this mild-mannered, religious woman received her peace in this life.

There is another note to this case: when Kathy and I were tape-recording our recollections of this investigation, at 7:20 p.m., into this

recording, we mention the malevolence of the spirit in Mary's home; at that point, a distinct EVP is heard in the form of an insidious growl. This set the hairs on the back of my neck on end. There's no doubt that ghost seeking is more than just a hobby, It's a way of life for the entire team, and anytime we can help someone or educate, we've served our purpose in this world.

ORISKANY BATTLEFIELD

Oriskany—In an investigation that would prove to be an incredible experience, the Ghost Seekers team and I walked the moor of the Revolutionary War battlefield at Oriskany, New York. This was an investigation into which we were very excited to delve. The Battle of Oriskany was considered the bloodiest conflict of the Revolutionary War. It was in the midst of the Saratoga campaign and pitted colonists from the Tryton County militia under the command of General Nicholas Herkimer against the king's troops and Loyalists under the command of Barry St. Ledger. The Loyalists had members of the Iroquois nation on their side, while the colonists had the Oneida Indians on theirs. The battle would break the Iroquois alliance. General Herkimer was wounded in the leg and died ten days later from the injury, according to Allan Foote. The toll from the battle was so great that the creek in the battlefield ran red with blood. The Battle of Oriskany earned the nickname "the Battle of Bloody Creek." Many of the dead went unburied for years.

In the century after the battle, it was designated a New York State historical site, and a towering obelisk memorial stands on the ground where many patriots had died, according to NYS Park, Recreation and Historic Preservation. Oriskany is in the heart of the Mohawk Valley and is a small village of 1,500 residents, yet it started out as a small group with the original name Oriska. Oriskany had the distinct honor of having an aircraft carrier named after it. The USS *Oriskany* sailed the seas from 1950 to 1976 and was dubbed the "Mighty O." The decommissioned USS *Oriskany* was sunk off Pensacola, Florida, and now serves as an artificial reef for a multitude of sea life.

We were to be stepping on sacred ground that had hosted the blood of patriots who died to free this country from tyranny and oppression. It was here at this most holy of battlegrounds that the Ghost Seekers team conducted what would become a respectful yearlong investigation.

A large orb drifting over the hallowed ground of the Battle of Oriskany.

One thing that I insist from my team is professionalism and respect no matter the venue of our work, yet the battleground required something extra special. Men died in combat here. Patriots and Oneida Indians died away from their families, brothers in death, spirits together in the afterlife bound to the sacred place of war.

I was contacted and invited by the curators of the Battle of Oriskany site. The curators told me that they and many visitors felt the presences of ghosts and spirits. My team on this venture consisted of myself, my sister Marlene McQuade, David, Gari McQuade, Kristen, psychic Marlene Marrello and Crystal. We began our first phase of the investigation on a bone-chilling night in October 2001.

We arrived anxious to get going, went to the main battlefield and immediately received temperature fluctuations on the thermal scanners. Ghosts will manifest themselves in waves of chilling air that we catch on the thermal scanners. It's these cold pockets that indicate that a spirit is moving about the area. Electromagnetic spikes were registering on the gauss meter, which told us that we were in the presence of ghosts. When in a home, wiring and appliances can give electromagnetic spikes; however, in the middle of a field at night with no wiring nearby, it had to be the spirits on the march. I

was having trouble with my camera as power was draining from the camera batteries. Flashlights and cameras were failing, so we knew that we were in the right location on the battlefield.

I and the psychic Marlene both smelled the scent of flowers, very strong. Then we witnessed a residual haunting in the form of a soldier. We all kept rubbing our eyes and wondered if this was really happening? When we finally realized that it was real, tears of disbelief and sadness streamed down our faces. How sad these poor souls seemed to be, stuck earthbound in this battle. This residual haunting was of a soldier pacing back and forth as if wounded in battle and seeking otherworldly medical attention. The soldier repeatedly drew his rifle and aimed it at the mist. Nearby, a tall man without a shirt stood to the right of this scene, watching.

I knew that this was a very rare experience and considered it a "Holy Grail" of all ghost hunters—something for which we all yearn. As the group approached, Marlene Marrello held us back, for she felt the hostility in the apparitions. I was entranced with this display and agreed with Marlene's insistence that we not interfere with the endless spiritual battle. I still can't believe what we had seen. It was rare, and we were appreciative to be witness.

A large ectoplasm mist at the Battle of Oriskany.

It was at this point that I sensed something along the northeastern tree line of the battlefield, so I had Marlene come over with the rest of the team. She immediately grasped onto the spirit I was gleaning and picked up the name "David" from a ghost along the northeastern tree line. We witnessed him trying to materialize in the form of white ectoplasm. He could not fully manifest into an apparition. He was confused and scared. The group witnessed him trying to materialize, but Marlene calmed his fears by asking him to cross over to the other side. Immediately his activity stopped, and he wisped away. We felt pained for the soldier that he was lost and pacing the battlefield and felt satisfied that he'd be reunited with his family.

It was not too long after this incident that the team again felt something, which caused Marlene to focus on a tree, where she picked up a spirit of a young soldier who'd been murdered by being hanged. This presence enthralled us. It was spooky. There was no doubt that the massive number of restless spirits was due to the heroic and tragic deaths on this most holiest of grounds.

It was then that Marlene Marrello and I picked up on a strong feeling of pressure along the northern tree line of bloody creek, with Marlene's psychic sensory overloading so much that she could no longer work in precision—there were far too many restless souls screaming and hollering from their spiritual plane.

The Ghost Seekers team showed its respect to the fallen dead of our country's birthplace by conducting a reverential investigation, which I felt was a huge success—receptive patriot spirits wished to move beyond their tragic deaths on the Oriskany battlefield. A complete report was given of our accounts to the regional administration of Oriskany battlefield. We truly believe this place to be haunted.

BEARDSLEE CASTLE

St. Johnsville—Beardslee Castle is one of the most well-known haunted places in the United States, having been featured on many television programs. The castle was built in 1860 by Augustus Beardslee, the son of a wealthy developer who worked on the construction of the Erie Canal. It wasn't until a fire gutted the mansion in 1919 that the mysteries of the castle began. The Beardslee family was away on vacation when the entire castle burned from within, leaving nothing but the stone exterior shell. All that was rebuilt was the first floor, and tunnels that had led from the property were filled.

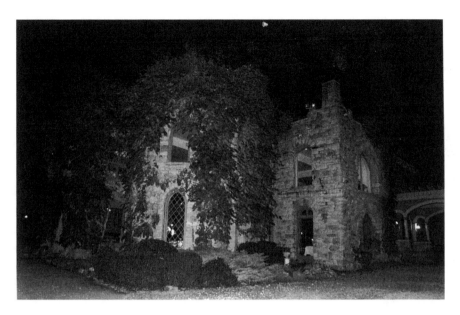

The vine-covered exterior of Beardslee Castle.

The next owner was Adam Horn, who later sold the property to Anton Christensen. The locals referred to him as "Pop," and the castle was known as the Manor for more than four decades before an aged and ill Pop hanged himself in the ladies' room of the castle.

The ownership then moved to John Dedla of Herkimer, New York, who operated the place until 1976, when he sold it to Joe Casillo, who ran it as Beardslee Manor. Mr. Casillo brought the first ghost hunter to the castle, Norman Gauthier, in 1983. The ghost hunter spent the night, recorded voices on reel-to-reel and played it for skeptics. Beardslee had another fire in 1989, which rendered the establishment useless and empty. Partiers and wild animals had their run until Randall Brown purchased the property in 1994, restored the castle to its previous luster and named it Beardslee Castle in honor of the original family.

Beardslee Castle has had a long reputation of paranormal activity that began in the 1950s, when travelers on Route 5 would see mysterious balls of bright blue and yellow in the vicinity of the castle. Many believe that they represent Mr. Beardslee walking the property with his lantern. The castle is also located in the town of St. Johnsville, which has been in existence since the first settlers came to the Mohawk Valley in 1775, according to internet sources.

I was very excited to dive into an investigation of Beardslee Castle; it is internationally known for its ghosts and spiritual interactions. Beardslee Castle has been on the History Channel, been part of the *Ghost Hunters* show on the Sci-Fi Channel and been written about in *Ghost!* magazine. The castle has been getting flocks of ghost enthusiasts since 1994, and there has never been a disappointment from voices, shadows and movements of objects.

I remember having gone through Beardslee Castle when I was young and remember having heard a woman's distinct, wild and uncanny laugh emitting from the roof, where nobody could have been. It didn't scare me like it would most children but rather enticed and thrilled me. This spark of the paranormal had always stuck with me, and my fondness for the castle would mean a dream fulfilled to investigate it. This dream became reality in 2007.

My team had been doing a joint, cross-border investigation with the Ottawa Hunting and Paranormal Group (OHPG) and wanted to bring its members along to Beardslee Castle. The Ghost Seekers team first went to Canada to investigate the Cornwall Jail in Ottawa, so when it came time for OHPG to come to the United States, I chose Beardslee as the place we should jointly investigate.

In March 2007, the groups headed to the castle together. There was still deep snow around the perimeter. The first place the group and I went with OHPG members was to the empty outdoor family mausoleum, entering the dark, frigid area around the crypt at midnight. Our breaths were large white puffs, and my teeth were chattering at the almost zero-degree conditions. Almost immediately, inside the macabre mausoleum, the analogue tape recorder that I was holding began to heat up, as did the area. All in attendance could feel the warmth of a spirit trying to manifest itself, yet it proved to be a spirit that matched the cold with its own chilly reception. Marlene had joined the group, and I had asked her to use her skills as a medium to read the sinister presence. This spirit told Marlene that we were not welcome in the area, which sent a chill even farther down my spine. I could tell by the reaction of all the seasoned ghost seekers that I was not alone in my feelings. This dismaying incident was captured on videotape.

We returned to the castle the next day, and I was eager to delve farther into the castle. We gathered together in the main first-floor room and were looking over the floor plan trying to determine the best locations for camera equipment placement. While Len, David and Ed were working

The bar at the legendary Beardslee Castle.

on this function, I brought along Marlene and Kathy to perform some EVP work with our digital voice recorders. It's theorized that spirits can speak in frequencies unheard by the human ear but that are easily picked up on a recorder. Later on, after the review of the evidence, we listen and determine if the sounds captured are otherworldly voices captured speaking to the living.

The rest of the team and I had also brought along digital cameras, for Beardslee Castle had long been known for pictures of creeping ectoplasm, spooky mist and malefic orbs. We would take hundreds of photographs of every nook and cranny of the castle and then later review the photographs for unusual paranormal occurrences.

I went with Kathy and Marlene to the first floor and spent a while asking general questions in the hopes of capturing something on digital recording, videotape or with our EMF readers. After some time, I decided to move my group down to the dungeon. We descended the stone steps and entered the musty and enticing dungeon, and I felt right away that the spirits would be attracted to this part of the castle. We went through a wrought-iron gate to a small, spooky room that hosted a simple table and chairs. We got interaction from spirits almost immediately, with our cameras constantly losing power, which could only be from a spirit that was trying to manifest

itself in the room. It's stated that when a ghost is trying to make itself seen in the mortal world, it draws power from the vicinity to make it happen; as a result, many cameras and digital recorders lose their juice.

We sat in the chairs and placed our digital recorders on the table. Kathy, Marlene and I were getting the feeling that we were not alone. I asked Marlene to reach out and use her gift to connect with any spirit that was from the past. Marlene struck pay dirt with an immediate conversation from an enchanting young lady spirit. She spoke via Marlene, saying that she was eighteen years old when her eight-year-old sister died in a tragic carriage accident. The spirit told Marlene that her sister's name was Estelle. I asked Marlene to query further into their presence, and the spirit said that she and her sister linger in the castle and travel back and forth between the scene of the accident and the castle.

When the spirit moved on, we did as well, going into another area of the castle—more interactions were to come, including some not-so-nice ghosts. Marlene was having her psychic skills put to the test, with angry, ominous spirits channeling to her that they only wanted family visitors. It was at this point that she connected with Jeremy, who explained that he'd been crushed by a stone (from the original construction of the castle) and lost a limb. When asked, "Was it a stone?" Kathy recorded an EVP of him replying, "Yes, it was." Later, in the same investigation, another frightening EVP of Jeremy stated, "I'm cold."

I would say that the joint investigation of Beardslee Castle between the Ghost Seekers team and Ottawa Haunting and Paranormal Group (OHPG) was a phenomenal success.

I was thrilled to have another opportunity to return to Beardslee Castle with my team when we were invited to take part in a 2008 fundraiser for the Herkimer County Historical Society. The group returned to the castle before the fundraiser for a mini-investigation in the hopes of adding more evidence to be included in our public presentation.

David, Kathy, Ed, Len, Marlene and I were excited to go back to Beardslee Castle and use our brand-new K2 meters, which detect spikes in the electromagnetic field. Many ghost hunters feel that a spike in EMF is the spirit trying to manifest itself. The ghost seekers will scan the area and eliminate naturally occurring EMF spikes from electrical wiring and appliances. The K2 meter has a series of lights that will illuminate to show the strength of the EMF field and will go from one light that indicates low levels to multiple lights to indicate increased EMF strength. At the top of the scale, all of the green and red lights will illuminate.

The first place Len, Kathy, Ed and I sat in was the banquet hall. We had our new K2 meter running, as well as video cameras and digital tape recorders. Len was asking questions, trying to communicate with the spirits, when the EMF meter starting going up to red, which is the highest level of interaction.

When we were leaving the second-floor banquet room, all of us were drawn to the left of the staircase, as if a person were there. This had happened periodically throughout the night, and only later, upon listening to the digital recorder, did we discover that we had picked up an EVP of a loud and rambunctious female laughing diabolically. I thought that it might have been the same woman I had heard many years ago. One separate and distinct voice, not the laughing female, responded to a query with a resounding "Right!"

Ed, Kathy, Len and I went down to the dungeon, where the video camera was running. I immediately received chills from necromantic cold spots, and the batteries in all of the flashlights died. Luckily, the ghost seekers are a prepared crew of spiritual hunters, so replacement batteries were in our vest pockets.

It's at this point in the investigation when I had a spirit directly interact with me to show its presence. As we were about to descend the steps leading to the basement, I reached for the flashlight in my vest pocket that would guide my way down the creepy stairs. I pressed the button to turn it on, and nothing happened. I made several attempts to light the flashlight, to no avail, finally coming to the conclusion that some otherworldly fingers had taken control of it, so I slipped it back into my vest pocket. Upon entering the pitch-black basement and heading for a small room, referred to as the dungeon, Len was bringing up the rear with his infrared camera rolling when he captured my flashlight coming on all by itself. I had not touched the button to turn it on. The button had not been pushed, nor had I run into anything to push the button. The device had been paranormally lit. I felt a wave of adrenaline come over my body as I had been directly contacted by a spirit that I considered an intelligent haunt.

The freakiest and best paranormal interaction at Beardslee Castle happened with the entire team together at the end of the night. We were sitting in complete darkness in the dungeon, asking the present spirits about the man who was crushed by the rock and the little girl, when an unoccupied chair moved back and forth several times on its own. This was captured on our night-vision digital camera. The entire group maintained a cool composure, and we thanked the spirits for the sign of their presence. When

it was asked to move the chair, again the scene was repeated. This was an amazing piece of paranormal evidence that gives me goose bumps every time I watch it. I was most proud of my team's professionalism. David, Ed, Len, Kathy and I have strict rules and decorum in place. We remained calm, cool and collected, even though we were all thrilled and chilled at the chair moving. It's important to be a cohesive set of ghost seekers.

Beardslee Castle fulfilled its reputation as one of the most haunted and spectral places in America. The rest of the team and I had collected evidence, and we were happy to have been invited by the owners to come and archive the spiritual movements within their fantastic, chilling castle.

HERKIMER'S 1834 COUNTY JAIL

Herkimer—The Ghost Seekers of Central New York team was invited to conduct an investigation into the Herkimer County Jail by Carol Hopson from the Herkimer County Historical Society, and I was thrilled at the opportunity. The jail was made famous when convicted murderer Chester Gillette was housed there after killing Grace Brown. The event led to the famous novel *An American Tragedy* and the movie *A Place in the Sun*. Gillette was a rich man who got Grace Brown, a poor girl, pregnant and then murdered her in Big Moose Lake. He was housed in the Herkimer County Jail and then electrocuted at the Auburn prison in 1908.

The jail is currently on the National Register of Historic Places and is owned by the Herkimer County government (via the Herkimer County Historical Society). It is located in downtown Herkimer, New York. The town was named after General Nicholas Herkimer, who was mortally wounded in the Battle of Oriskany.

Besides Chester Gillette, the Herkimer County Jail housed numerous criminals. It has a long-standing reputation as being haunted and filled with unexplained, harrowing phenomena. I along with the rest of the Ghost Seekers gladly accepted an invitation and agreed to have a public meeting afterward to reveal our findings.

When we arrived, we did a walkthrough and initial EMF sweep to determine the best locations for our video cameras. We set up all of the equipment, with Len leading this charge with his military precision. When we were finished setting up and ready to roll, we did what we always do on all of our ghost investigations: held hands in a circle and said aloud our protection prayer. We believe that this keeps evil spirits at bay and allows the

The jail cell of Chester Gillette at the 1834 Herkimer County Jail.

ghosts to come forward without fear. We do not wish to interact with demons or malevolent spirits. As a spiritual adventurer, one has to respect the ghosts and not challenge or bait them into our plane. You must be respectful. We only wish to interact with friendly and willing apparitions.

The entire team went into the basement to begin the investigation. From what I could surmise, it still had the same look from the 1800s, with no modernization. The darkness and mustiness heightened the sense of dread and creepiness among the team members. I had a deep feeling that there was a spirit in our presence, one that had with it waves of sadness and dread. Then, there it was, a spine-chilling shadowy movement in the hall of the basement.

Kristen, Carol and Marlene were walking through the basement cellblock when the gauss meter spiked up to an 8.0. Upon further investigation, it was determined there was no exterior electrical interference. We believe that this was a spike caused by the presence of a spirit from the other side. One thing we always do before an investigation is a pre-walkthrough, during which we log base readings before the official investigation. The large spike in the gauss meter was, without a doubt, the indication of a presence, for it was not there in the earlier walkthrough.

Kristen, Carol and Marlene were investigating the cellblock when a mysterious insidious force pushed Marlene from behind, sending her crashing onto a metal bed into one of the cells. The incident freaked out Kristen and Carol, who fled the scene and then went back within seconds to retrieve Marlene, who was shaken up by the incident but not frightened. This was an extremely rare incident in which two of my team members lost their composure. We delve into some dark places and have had creepy interactions, but one can never predict the reaction to a shove from a ghost. It's exceedingly rare for an entity to interact physically with the living, especially to the point of a shove that knocks one off their feet.

The entire team felt extreme sadness within the confines of the jail in the area where the female prisoners were housed. I had a gloomy feeling that I couldn't shake. In the same cellblock, the infrared cameras couldn't autofocus and kept adjusting all night long, something not noticed by Len before or after the investigation. It was likely the female spirits of the jail reaching out and manipulating the operations. Len is meticulous with the equipment, and there was no camera defect with regard to the autofocus before or after this incident. Spirits will do this when they are entering into our dimension yet are not yet there fully, like a mortal person. That's why the camera couldn't quite focus on the ghost, for it was bouncing back and forth between two realms that the camera couldn't track.

An entity begins to form near the entrance to Chester Gillette's jail cell at the Herkimer County Jail.

I had decided to take my team up to the second floor to enter the jail cell that had housed Chester Gillette when a presence attempted to manifest itself. Three 35mm pictures were snapped in succession that later revealed the profile of a man in the cell coming into full form. This was also caught on video camera at the same moment, giving us verifiable proof of the haunting of the Herkimer County Jail. This haunting evidence was captured at the same time by two types of ghost-hunting media so it cannot be debunked.

One thing that the Ghost Seekers team always does is go back over all the digital, audio and photographic evidence of a place it has investigated. It's a long, tedious process in which we debunk everything and only clear the most positive evidence. We're picky about what becomes the final evidence. Upon further review of the Herkimer County Jail, many large pulsating orbs were photographed inside and outside of the jail. Many times, orbs can be debunked as dust particles, snow, rain, mist and other interferences. After many years and many investigations, I can tell when an orb is genuine and not from dust particles. Also, we had a terrific EVP when a recognizable audio track of a ghostly heartbeat was heard in front of Chester's cell and was captured on digital audio. I along with the rest of the team came to the conclusion that the Herkimer County Jail is extremely haunted.

WAYSIDE INN

Elbridge, New York, is a nice little slice of Americana. A small Central New York town of six thousand residents nestled in Onondaga County, it is named after Elbridge Gerry, a vice president of the United States and a signer of the Declaration of Independence. The town of Elbridge just happens to have one of the most haunted places in the country: the Wayside Inn. I was very excited to be taking the Ghost Seekers team to the Wayside Inn for an investigation.

The inn has had many owners over the years and has a long history of eerie haunted activity. The Wayside Inn has been a pub, as well as an auction house. Ed originally read about the location and brought the idea to me and the rest of the team to perform an investigation there. Tim Conroy was the owner of the building and was renting it to Margo and Roger Spain.

The Ghost Seekers team went and did the preliminary walkthrough. Tim reported to us that he was behind Margo, climbing the stairs, when she was pushed from behind by an invisible entity that knocked her forward. Another witness at the top of the stairs saw this as well. An

A large orb in the Wayside Inn.

ominous, full-figured shadow person or apparition was fading in and out of sight of everyone and would step forward and back, giving an indication that it was an intelligent haunting. I knew that by having an intelligent haunting, it would make the investigation into the Wayside Inn more chilling and dangerous.

The rest of the team and I were informed that on the auction side of the house, people would be pushed and poked by an aggravated spirit. On the bar side of the inn, there's one corner where glasses move or are broken, and there is a continuous needling of the living by the dead bar patrons. Legend speaks of one night when a ghostly woman who was sitting at the bar went to the ladies' room and was never seen again. Her spirit went in and never came out. Disturbed and frightened patrons called the police, who came and walked the perimeter and interior of the Wayside Inn; the spiritual patron was never found, but her cigarette was still smoldering at the bar.

The Wayside Inn is a large building, with three floors, so I knew that the Ghost Seekers team would have a lot of area to cover. The fearsome third-floor room had the uncomfortable moniker of "the suicide room" for the suicide of a former guest.

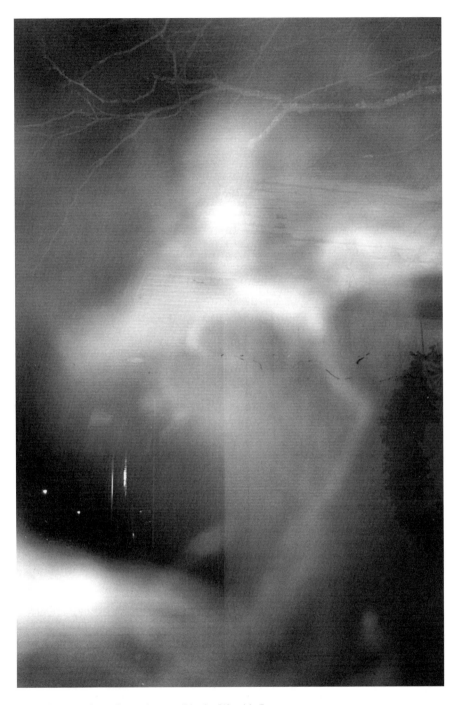

A massive ectoplasm formation outside the Wayside Inn.

The owners mentioned to me that a workman had been hired to remodel the second floor and kept hearing creepy voices and experiencing other unexplained, frightening phenomena—to the point where he walked off the job, vowing to never return. Tim and his wife personally witnessed a glass coming off a coffee table in their second-floor office that was thrown by a pissed-off entity into the wall, where it shattered.

Kathy had spoken to Fred Webber, who had run the Wayside since 1993 and said that the place was highly haunted. Fred's wife was in the second-floor office when a wicked ghost grabbed her by the arm; visible marks of the assault remained. Joe Johnstone*, the bartender, would close up the place, blow out all of the candles, leave the room and come back, whereupon he'd find all of the candles relit. He'd do this several times and would even shut all of the lights off and go out to his car, only to see illumination in the windows. He'd go back into the bar to find the candles once again relit. This happened so many times that Joe considered it part of his job routine.

The Wayside became nationally famous for having a national television reporter in the 1970s report on the spirits, as well as for hosting many large gatherings of psychics. Many mediums claimed formidable visions, making the Wayside the place to be for paranormal curiosity seekers. The main ghost was seen so much that the owners and patrons started calling him "Harry."

Fred talked about a housekeeper named Lori Grouse*, whose husband saw her having an affair with a carpenter. Her husband died suddenly, and then the paranormal activity rose up, so everyone started calling the spirit Harry, after Lori's dead husband. Fred also talked of the little girl he'd seen at the top of the stairs, as well as the frightening tale of his granddaughter. She was a small girl at the time, and she'd have sightings of a grim, ghostly woman sitting on their couch. His granddaughter called her the "lady with the funny eyes."

The Wayside Inn has hosted many dances in the past and also has rumors of a dead person in the well of the basement. One night, Fred thought that there were burglars breaking into the establishment and called in a state trooper, who spent the entire night inside the Wayside, or at least until 4:00 a.m. The trooper kept hearing toilets flush, people talking and footsteps, yet every time he thought he had suspects, he'd find nothing but air. The perpetrators were ghosts creating tomfoolery and vanishing into the shadows, all in the name of having fun with the man in uniform.

Dave, Ed, Len, Carol and I went there for a full interview from the owners. Not long after we were seated at a table for discussion, someone

Mist forming into a shadow person at the Wayside Inn.

whispered in my ear, "Hey there." No one was seated next to me. I was startled to say the least, yet it was not felt or heard by anyone else. As soon as this incident concluded, a glass that was on the fireplace mantel was flung across the room.

The team set up its equipment on the second floor and in the suicide room on the third floor. The first investigation would be challenging, for the downstairs bar remained open. This interference would cause us to question evidence, especially EVPs, so I decided that it was best not to run EVP sessions until the second night of our investigation, when the place would be closed.

We broke up into teams, so I went with Kathy and Kristen up to the second floor, with Ed, David and Brian going elsewhere. Kathy and I were sitting up on the second floor all alone and kept hearing the doorknobs rattle. We couldn't debunk the evidence, for there was nobody around, and it kept happening on multiple second-floor doors.

When Ed, David and Brian were in the suicide room, they kept getting a dire, uneasy feeling, with Brian being pushed from behind by a gruesome spirit. As soon as this happened, Brian felt queasy, so he left the building. This is not an unusual occurrence when you're on a ghost-seeking investigation. He did the wise thing by leaving, for it was an indication that the spirits were not happy with his energy. Later on, the cameras in the

suicide room captured a flurry of orb activity. At the end of the first night's investigation, Ed went outside the Wayside Inn and captured a multitude of grisly ectoplasms and a ghoulish shadow person roaming the perimeter. I was thrilled with the evidence from the first night and was excited to try the EVP on the second night.

On the second night of the investigation into the Wayside Inn, we were able to utilize the digital recorders and acquire some EVP. Many times, team members will not pick up any videotape or photographic evidence of spirits, yet upon playback the digital recorders will have interactions with the living. It is theorized that the dead speak on different frequencies, with some not recognized by our human eardrums. The ghosts do not realize this difference between our dimensions, so the EVP sessions are critically important to any investigation.

Kathy, Carol and I decided to sit in the bar area and ask questions to try to get the ghost that everyone called Harry to interact with us. All of the patrons referred to Harry as a "troublemaker," so when asking questions, Kathy decided to challenge Harry by calling him a troublemaker and telling him that he should "show" them just how meddlesome he could be. As soon as Kathy finished challenging Harry, the ice machine in the bar turned on, making everyone startle. Later on, while listening to the digital recordings of this incident, a distinct and insidious male laughter can be heard right at the moment when we were startled by the ice machine turning on. It seems that the patrons of the Wayside Inn were correct that Harry was fun, mischievous and devilish.

For the longest time on the second night, when we were on the first floor, we kept hearing walking and footsteps on the second floor, even though there was nobody up there. Kristen reported hearing loud whispering from the library upstairs while combing the area for temperature fluctuations. I found the Wayside Inn to be a most fascinating investigation, and all the haunting claims made by the owners and patrons seemed true. In my opinion, as well as that of the rest of the Ghost Seekers of Central New York, the Wayside is highly paranormal and well deserving of its reputation.

ERIE CANAL VILLAGE

Rome—I was excited to get the opportunity to have the Ghost Seekers team investigate the buildings and grounds of the Erie Canal Village in Rome, New York. According to the Erie Canal Village website, it sits on the location

that was the very first place excavated for the construction of the canal. There are many buildings on the grounds, as well as a horse-drawn boat that recaptures the canal travels of the nineteenth century.

The investigation took place in March 2008 and included many building on the grounds. I was contacted by Melody, the museum director, who told me that the older buildings had been donated and relocated to the grounds, with most having been constructed in the nineteenth century. This gave the team a jolt of excitement, for it is well known in the field of ghost seeking that remodeling or movement of old buildings can cause a disturbance of spirits that can result in acting up and interacting with the living world.

The first night of the investigation, I knew it was going to be tough, as Route 46 was adjacent to the campus, which would make cars going by interfere with our outdoor EVP work. It was also a rainy night, and the bugs were out in abundance. The Ghost Seekers team has done investigations in all kinds of weather conditions and in and out of a multitude of structures, so we'd have to be as flexible as we always have been.

The first structure we investigated was Bennett's Tavern, which had been a dance hall in the nineteenth century and then later a private residence. Melody told me that she preferred to stay outside and watch our investigation from there. Kathy and Marlene both stated that they felt the presence of a female entity. As soon as we stepped on the porch, a rocking chair started to move back and forth, as if a ghost were lounging and relaxing the night away and happy to have company.

The first room we entered had an immediate hit of 8.2 on the EMF gauss meter. The three of us proceeded to the piano room, sat down and started to work on some EVP. After a brief time, I noticed that the tablecloth was moving. Then Kathy pointed to an area by the piano, so we snapped a picture that later showed a bright, sizeable orb. When you get as familiar with a team as I am with mine, and have conducted dozens of investigations, you start to work like a well-oiled machine. I knew exactly what Kathy was referring to when she pointed, and thus we had more proof of the paranormal.

Len had decided to stay by the monitors, and he watched on camera as multiple orbs were seen ascending and descending the stairs. There was no doubt that there was a high amount of paranormal activity going on at the tavern. I went up to the servants' quarters with Ed and Marlene to do some EVP work. We were asking lots of questions, and only later did we find that something was clearly talking back to us in a language that none of us understood. With a little research, it was discovered that the language was Pennsylvania Dutch. Later on, Kathy and Ed were up on the second floor,

A large orb above a rocking chair at the Erie Canal Village.

conducting EVP work; when they asked certain questions, a washboard that was sitting on the dresser would vibrate in response. There was no doubt that Bennett's Tavern was a fantastic start to our investigation into the Erie Canal Museum.

The next building we went into was a small cottage that was built in the nineteenth century, referred to as the Crosby House. When we walked in, I was captivated by the charm and was raving about how cute the cottage was and how much the owners must have loved it. Later on, when we listened to the digital recordings of me making these comments, a distinct voice is heard responding, "I do too!" Another voice during the same session clearly states, "I love it." When we looked further into the time this EVP happened, a clear orb was photographed hovering by my head.

We had Steve, a member of the staff at Erie Canal Village who is an engineer and author, work with us on some of the investigation. He decided to sit in a rocking chair in the parlor. It was a warm evening, and he felt chilled to the bone, but only when he sat in the rocking chair. When Steve got up and walked away, the chill went away. Len sat in the same rocking chair right afterward to confirm this, and he was also chilled right away. We snapped a picture at this moment, and it showed a huge,

spooky orb hovering above his right hand. We had company. That made two terrific paranormal experiences in two buildings. I was thrilled with the start of the investigation, and we still had some buildings and grounds to go through.

The next building that I went to was the blacksmith shop. We set up the same video cameras and had our digital recorders and our gauss meters. For the first time in the evening, some of our equipment started to fail, which told us that there was spirits present. My camera mysteriously stopped working, yet it had been in perfect functioning order just minutes before. It was that strange, restless presence from another world reaching across into our dimension and tinkering with the technology they didn't have or were curious about. Or perhaps the spirit was shy to be seen or unwilling to be revealed. We picked up two extremely weird and eerie pieces of paranormal evidence in the blacksmith shop. Later on, when we were listening to the EVP sessions, a woman's distinct and bone-chilling laughter is heard. Also, David took many photos and picked up an insidiously delicious ectoplasm that gave us all the chills.

On the second investigation, I decided to go with Ed and Steve down the grassy black path to Fort Bull. I had my digital recorder going, and I had said to the guys to not whisper since that can be thought to be a ghostly EVP. It was at this point, when we later reviewed my warning, that a clear, curt response from a ghostly voice says, "Don't start!" It was a very clear response and not from anybody in the group. I had a profound sense of sadness. We continued our journey to the Fort Bull monument. Digital photos were taken, and when these were later reviewed, they revealed intrusive ectoplasm surrounding Steve and I; in another photo, a curiously strange orb was hovering in front of me.

We took pictures all over the campus, and what was revealed later sent shivers down our sturdy spines. We photographed an eerie picture of ectoplasm hovering over what was reported to have been the location of the mass grave of those who died in the Fort Bull massacre. It takes a lot to chill our blood, since we've been conducting paranormal investigations many times for many years; however, this photograph of the phantasm ectoplasm did its intended frightening deed.

The last place in the Erie Canal Village that we investigated was the Schull House, a beautiful Victorian home. It was on the third floor where David and Len captured an amazingly striking piece of evidence from the other side. They were in the servants' quarters, asking questions and running the digital recorder. Len asked, "If there's a spirit in this room,

please knock once." Immediately, in response, a singular knock is heard that was loud enough for David and Len to hear it, and their reaction to it was caught on the video recorder. Len and David saw a light above a window in the Schull House servants' quarters and couldn't debunk it. As we all walked the main staircase and the parlor, our K2 meters were spiking highly and regularly.

I would say that the Erie Canal Village was one of the most haunted places that the Ghost Seekers of Central New York had ever investigated. It was a beautiful place, and the team was overjoyed with the solid evidence it had collected. The investigation was followed by a public presentation of the evidence of paranormal activity collected there. A subsequent investigation was scheduled for summer 2009.

SEASHELL INN

Sylvan Beach—I was contacted by Pat DePerno, the owner of the Seashell Inn, to come and conduct a paranormal investigation into her establishment. I had heard the stories for many years about the Seashell Inn, and when I mentioned the opportunity, the Ghost Seekers members were excited at the chance to investigate the famous haunted establishment. I spoke with Pat when we arrived, and she mentioned that the establishment was built on Indian land. She also told me that the husband of a prior owner had been electrocuted to death while working on the deck. Pat and her entire family had experienced apparitions and ghostly voices in the home that once stood beside the restaurant. Pat's wheelchair-bound mother-in-law lived in the home with Pat, and her husband witnessed something other than a human slap her mother and also one day found the poor woman inexplicably trapped behind the couch. This stirring and disturbing spiritual abuse could never be explained.

Pat described waking up once at midnight to the sound of a distraught female crying outside by the water, and when she looked out the window at Oneida Lake, there was a woman in the water. She woke her husband, who also heard the crying and saw the woman in the lake, yet when they went outside to see if she was all right, she had disappeared. It had been a female Indian ghost. In her research, Pat found out that there's a legend in Sylvan Beach of long ago, when an Indian woman who was in love with and wanted to marry a white man was prohibited from having the marriage—she drowned herself in sorrow in Oneida Lake.

A paranormal streak at the Seashell Inn.

Pat told me that her husband was a nonbeliever in the paranormal, even after the midnight crying, yet he was soon to turn his opinion around. Pat's home next to the Seashell Inn was moved off its foundation by a spring flood. It needed to be taken down, so she asked the fire department to host a controlled burn. With her husband and many people in attendance, the empty home was set afire, and in mid-blaze there were multiple ghastly screams, heard by all, coming from inside the home. Pat also mentioned to me that she had a young man working for her at the Seashell Inn who claimed to have a sensitivity to the spirit realm and who had to quit—the offensive spirits on the property next to the restaurant were tormenting him. The staff had also reported to Pat that they were seeing apparitions in the mirrors in the ladies' room.

When we did our investigation, the restaurant was closed, and the night was a very windy one. The first place we wanted to go through was the upstairs apartment, since Pat relayed to us that her son had experienced a certain phenomenon there. He had been in the bedroom when he clearly heard footsteps coming up the stairs and then walking down through the hall to the bedroom. Suddenly it stopped. He expected to see his mom there in the hall, or at least in the stairway, but there was no one there. Pat led us up

An exterior orb at the Seashell Inn.

the stairs, with Len running a hand-held video camera. She had turned on the light, and when we were halfway up, something unseen decided to put us in the dark. This strange event was captured on video.

I was in the upstairs apartment with Kathy and my flashlight, and our recorders kept failing. Kathy and I had an overwhelming sense that there was a presence in the room. Kathy was taking pictures, and upon reviewing the photographs, we discovered a stunning pink energy streamer moving left to right. While we were upstairs, David, Len and Ed were in the bar taking photos, using the digital recorders and running the video cameras. Later on, when the team reviewed the evidence, many terrific orbs were observed.

At midnight, the team was outside the Seashell Inn, taking pictures and taping the perimeter, when members heard a woman screaming down near the water, which made their blood run cold. There was nobody there, and this ghost woman's angst from the other side was clearly caught on a digital recorder. I wondered if this could've been the same woman of whom Pat and her husband had spoken. Eerily, when I checked the time of this event, it was on-the-button midnight. This is referred to the locals as the "12 o'clock cry." The legend also dons the cover of the Seashell Inn's

menu. I felt that we were lucky to have heard the woman's cry. Another creepy EVP happened outside when Ed said, "I'm moving over here," and a mystic voice that didn't belong to anyone present replied in a coarse manner, "Bring it here!"

On the way home from the investigation, I was locked out of my car by something unseen. It was caught on camera, with Kathy taking a photo right when this happened, and there was a large orb hanging right over my head. I would say that the investigation at the Seashell Inn was very successful, and I'd love to take my team back there to perform another investigation, particularly of the area where the original homestead stood. It's a thrilling yet frighteningly active paranormal area.

MUNN'S CASTLE

Rutger Park, in the city of Utica, New York, is lined with gloriously built mansions from the nineteenth century that were occupied by politicians, powerbrokers and builder barons of the glorious city adjacent to the Erie Canal, now the Barge Canal, and the Mohawk River in the midst of the Mohawk Valley. Utica was designed as a monocentric ("spoke and wheel") city that boasts a spoke-and-wheel design meant to utilize its waterways and rail systems. The Rutger Street mansions were built to overlook the downtown that would drive Utica to great economic and political heights, especially during the industrial revolution. Drive through Rutger Park, and you'll marvel and gape at these handcrafted mansions that have recently been restored and placed on historical registries.

The Ghost Seekers team was invited to conduct an investigation by Mike Bosak, the president of the Landmarks Society of Greater Utica. Mike was having a fundraiser for the Landmarks Society and had asked us to give a ghost tour of both Rutger Park Mansion No. 1 and No. 3 to interested supporters. The group met and decided that we would help the society, but we had to investigate both mansions on our own first to try to verify all of the claims of the paranormal. The fundraiser for the Landmarks Society was to be held on the evening of Saturday, October 16, 2010. We decided to investigate Rutger Park Mansion No. 1 first and slated the date for June 26, 2010.

When we pulled up to the mansion that is Rutger No. 1, the entire team gasped at the beauty of what looked like a castle right in the heart of Utica, New York. The city has always been known for its open arms for immigrants

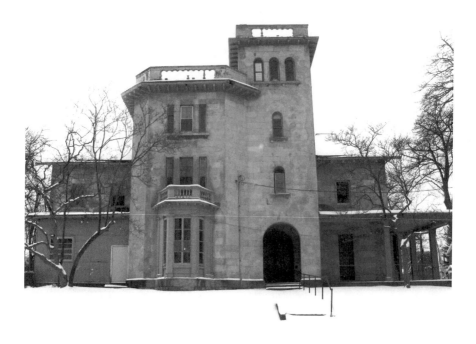

Munn's Castle, Utica, New York. *Dennis Webster.*

and refugees, and this was the direct result of the hardworking craftsmen who built the city one brick at a time with their rugged, creative hands. Rutger Park Mansion No. 1 was built in 1854 in an Italian villa style and designed by the famous national architect Alexander Jackson Davis, according to Mike Rizzo. Mansion No. 1's most famous occupant was the world-renowned gun maker Samuel Remington, who lived in the mansion during the Civil War. The mansion was called Munn's Castle after the original occupant, banker John Munn. The plans that were made by the architect of the mansion are held in the archives of the Metropolitan Museum of Art.

When the team first arrived, we gathered up the equipment for setup. Marlene Marrello and I did a walk of the outside perimeter of the mansion. We felt that the exterior was compelling and that its beauty was drawing us in. I felt that the mansion was as intriguing and inviting a place as I had ever investigated. We all knew that there was a long life to the mansion, and the beauty and dignity of the structure only excited us to dig in and get into the mansion. We'd been told by Mike Bosak that the caretakers and many others had experienced ghostly occurrences in all levels of the home, from

Orbs in the attic at Munn's Castle.

the basement at the lowest level to the turret up at the peak. I was especially drawn from the outside to the turret that was nestled at the apex of the three-story structure.

When we walked into the mansion, I felt a feeling of overwhelming dread, which members of the team confirmed with their own senses. It was as if the euphoric exterior shell was nothing but a spiritual veneer to the inside. Kathy went into the library located right off the foyer and felt an evil, malicious presence that hung around her neck and wouldn't get away from her until she returned to the foyer. This type of feeling permeated the team, with Ed and Len feeling the darkness of the place even on their outside walk. Ed went all by himself into the basement of the mansion to set up equipment and was creeped out worse than in any investigation he'd ever been on, which amazed me. Normally, Ed has ice water in his veins on these ghost hunts, yet he had several instances within the basement when he felt something on top of him, causing his hair to raise on his arms and neck.

We decided to start the investigation on the first floor, where the entire team gathered chairs and started our EVP session. It was at this point that we started getting strong spikes on our K2 meters. This coincided with a trembling, disembodied voice that we picked up on the EVP session. Of course, we were doing our investigation in total darkness. We had four-way

cameras, which all have night vision. When we were in our chairs doing the first-floor session, Len caught in the doorway a shadow person darting back and forth. We got feedback from Marlene Marrello that there was a female spirit present in an elegant red dress, as if she were attending a fancy afterlife party. This sent chills down my spine, for in an earlier meeting with the Landmark Society, the entire team and I were at a social event when a man whom none of us knew approached Len and said that he was sensing a female entity in a red dress strolling through the event and surveying what the ghost seekers were doing. I could only surmise that this strange man was a psychic or a medium. There's no doubt that the lady in red roams the grounds and mansion. When we reached out to her with questions, we received back distinct knocking and clicks that were picked up on EVP. I considered this an intelligent haunting, for the responses were in step with the queries that we were sending out to the lady. Other responses came when we would knock on wood and get a rap back from the spirit world, and also there was an extreme number of orbs floating and drifting through our session, as well as massive spikes on the K2 meter.

The most thrilling and creepy paranormal integration occurred on the second floor. I went up there along with Kathy, Marlene, Dave and Todd, who was filming the events of the evening. We found a mirror that had been covered up by a drapery in one of the second-floor bedrooms. There's a theory that when a person dies, you cover up a mirror, for it can become a spiritual portal to a negative realm. I decided to allow the drapery to be removed so that Marlene Marrello could perform a scrying in the hopes of establishing a link with the other side. Scrying is using a device like a mirror in the attempt of getting a spiritual appearance. Kathy, Marlene and I sat on the floor in front of the mirror, meditated and cleared our minds, while the men stood back.

Almost immediately, Marlene picked up a presence, and we could see a spirit in the reflection of the mirror that was behind us and standing by the bedroom window. Within a timeframe that seemed rather lengthy but I'm sure was only seconds, another spirit arrived for us to see in the reflection in the mirror. We were now looking at two people, and it was at this precise time that we picked up a strong and clear EVP that said, "Twins." It is times like this when I'm most at peace, even though the adrenaline rushes and my heart thumps in my chest, I know that I have to maintain my composure, especially with my team members in the room. I picked up my walkie talkie and spoke to Len and Ed, who were outside. I asked them to try to take a picture of the second-floor bedroom window from the yard and asked them

Ectoplasm mist in the archway of Munn's Castle.

to let me know if they could see any ghosts in the window. During this event, Dave and Todd witnessed an orb that came pulsing and drifting through the room and sailed over Kathy's shoulder.

After the team's excitement for the events in the second-floor bedroom, we got up and decided to explore a little bit more. Dave and Todd found a room that was off the back corner of the bedroom. Kathy looked in there and saw a shadow figure lingering in the back corner. We all paused while Marlene stepped forward and confirmed Kathy's sighting. Then she used her psychic gifts to communicate with the spirit, which said that her name was Theresa. Kathy was floored by this revelation, for her favorite patroness is Saint Theresa, who is the heavenly guide of all foreign missions and is referred to as the "Little Flower," according to Paul Burns.

After this, Marlene interacted with two more spirits, first one that said she was dressed up and had been to the mansion for parties and then another spirit that revealed his name to be John. We picked up a clear and distinct EVP that said, "Poor John." Another interesting paranormal event occurred with the old nurse call phones that were still hanging throughout the second and third floors. These phones were completely cut from power, yet during the investigation we'd pick up the receiver on them—you could make out what could only be described as the guttural sounds of the dead trying to communicate with the living. I checked along with others, and the lines had been cut, in addition to the lack of power. These eerie sounds and echoes from the spirit world were enough to rattle the most hardened ghost seeker. The entire team tried it out and were speechless at the sounds from the grave. During this time, the K2 meters were pegging all the way to the red indicator light, which tells us that one of the strongest spirits is present.

We then decided to leave the second floor and climb up to the turret. We ascended the creaky, steep, narrow old stairs. In many cases, spirits will float to the top of a structure as if they want to rise, but only as high as the highest place holding them to this earth will allow. I opened a little door that creaked and groaned on its old, rusty hinges, wiping away dusty cobwebs. Looking up that darkened and ominous stairway, I had a feeling that I just did not want to go up there; however, I have had this feeling in the past yet sallied forth for the good of the team and also to satisfy my otherworldly curiosity and spiritual ghost-seeking duty. Marlene informed us that the spirit that had identified himself as John had followed us up there. He was trying to let us know that he had been harmed in some way during his mortal life. We all agreed that for this degree of distress he must've been murdered.

A paranormal nurse calling to the living at Munn's Castle.

The air in the turret was stale and gritty, with a thick dust to it that made it almost impossible to breathe properly. I waved my hand in front of my face, thinking it was disturbed dustings that were being brought up, but it had more of a paranormal flow to it that made me feel uneasy. I picked up a spirit channeling from a ghost that was not John. The channel was clear and intense. This other presence informed Ed that

he had been up there and that other men were hurting him—badly. He revealed the means of his death: he'd been pushed down the steep stairs and died from a broken neck. I picked up on this spirit, and he conveyed a sense of relief and release that he had communicated his story to the land of the living. It was an eerie event that spooked everyone on the team, yet I felt proud that we had banded together and assisted this ghost on getting his tale out to the mortal realm.

As an interesting and scary side note to the Rutger No. 1 investigation, I did some further historical investigation into our mysterious ghost named John and came across a revelation. In a newspaper article from the nineteenth century, I read of the gruesome hanging that occurred in the village of Utica in 1817. This was the first hanging in the brief history of the village. The place was not yet large enough to achieve the population moniker of city. Anyhow, Joseph Tuhi had killed his brother, John, after a drunken quarrel in the village of Clinton. They were looking for a place to hang Joseph, and the spot ended up being the backyard of what is now Rutger No. 1.

On July 25, 1817, a large crowd gathered to witness the execution. Sheriff John Pease sat on a horse and condemned Joseph Tuhi to death. The sheriff was in his full military uniform, rode up the scaffold and swung his saber, cutting the rope that held up the trapdoor. Joseph was hanged from the neck until dead. Marlene made the connection that John was hanging around Rutger No. 1 to tell his story and also guard the body of his brother who, we theorize, is still buried somewhere on the property in an unmarked grave. These are the kinds of revelations and experiences one can only imagine when you get into the ghost-seeking game.

The group then went all the way back down into the basement, where Ed had reported being extremely freaked out and spooked by whatever lingered in those dusty old cobblestone foundation corners. It was in the basement where the entire group partook in something scary, satisfying and rare: ghostly intervention. Marlene encountered the spirit of a little boy who was cowering in the corner. He told Marlene that he was afraid of the light. He was afraid to go toward it. We picked up a clear EVP of the boy ghost saying "No" to one of our requests to move on. He preferred to stay in his plane of existence in the basement of the mansion. Marlene, with the help of the energy of everyone in the basement, coaxed the little boy to go to the light. We communicated to the little boy to not be afraid of what awaits him on the other side of this world. The little boy trusted us that he was moving on into a better place and walked into the light. The entire group was moved

emotionally by the intervention. Rarely do we get to assist on something like this. This strengthens my spirit and charges the group's mission that we're doing positive work for our spirit friends on the other side.

The group, as a cohesive collective, came to the conclusion that Rutger No. 1 was one of the most paranormal and haunted locations we had ever investigated. I'd never seen the K2 meters peg to the top the way they consistently did at Rutger No. 1. It's a building that's overloaded with paranormal activity and darkness. The place has a dreadful cloud hanging over it, and I would caution those who are curious about the paranormal to be careful in their interactions with this place.

ROSCOE CONKLING MANSION

Rutger Park Mansion No. 3 has a long history of hosting political powerhouses, including its most famous occupant, Roscoe Conkling, who was a powerful national political figure in the nineteenth century. Roscoe Conkling had been the Oneida County district attorney, mayor of Utica, served in the United States House of Representatives, was a United States senator and ran for the presidency in 1868. He was also nominated to the United States Supreme Court in 1882 but was denied. He was considered the most powerful Republican in the United States. Conkling was also married to the sister of Horatio Seymour, who was considered the most powerful Democrat in the United States. Rutger Mansion No. 3 had also been the home of United States senator Francis Kernan and Judge Morris Miller, according to the Landmark Society of Greater Utica.

Rutger Mansion No. 3 was built in 1830 and was the first mansion built in what would later become a hub for the most beautiful structures in Utica—a place for the rich and powerful. Albany architect Phillip Hooker designed the mansion and placed a lavish circular garden directly in front. Although time has not been kind to the mansion, it still is a magnet to the eyes as you drive by. One can only imagine the political discussions and policy made among the lavish rooms and garden. I was thrilled that we'd be given the honor of conducting a ghost investigation in such a significant historical location.

I arrived with the team, and we paused in the front foyer to admire the personal craftsmanship, which you just don't see in any modern structure. It's as if these older mansions had souls and identities of their own. They're one-of-a-kind and unique structures. We moved to set up all of the gear

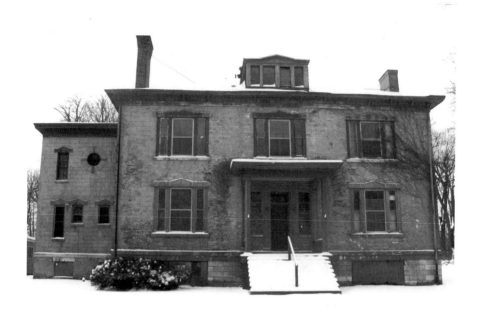

Roscoe Conkling's mansion, Utica, New York. *Dennis Webster.*

throughout the house and conducted our standard protection prayer that allows the spirits to know that we come in peace and respect. We mean them no harm and open our hearts and minds to them. I'm convinced that this is the reason why we have such success in our investigations—we seek peace, interaction and understanding with the spirits. The people from the Landmark Society of Greater Utica had made the statement to me, "If only these walls could talk." Well, we were soon to find out they could do a heck of a lot more than talk.

Along with Dave, Kathy and Marlene Marrello, I went into the first-floor library and started an EVP session by trying to contact Roscoe Conkling. It's been told that Conkling had been having an affair with Katherine Jane "Kate" Chase Sprague, whose father, Salmon P. Chase, had been the treasury secretary during the Lincoln administration and was the wife of Rhode Island governor William Sprague. The rumor was that Governor Sprague caught Conkling and his wife together on his Rhode Island mansion property and chased Conkling off his property with a shotgun. Conkling was known as being flamboyant, powerful and egotistical, as well as a strong political force. I felt that if his ghost were in the mansion, he'd

not be shy about making his presence known. I knew that the place would be a hotbed of activity, for Len and Ed were getting high readings on the K2 meter as they did their perimeter sweep and pegged especially high numbers while on the front porch. The mansion had virtually no electricity that could cause false readings, and there was nothing on the grounds or front porch to do this. It was as if the paranormal veil was opened and the spirits were strolling through the garden, around the home, up the front porch and into the mansion. They were awaiting our arrival.

I was standing near the fireplace on the first-floor library when I spotted what looked like smoke filling up in the hallway. It looked like a wall of smoke, and it alarmed me so I informed the others, who confirmed what I was seeing. It was at this point that my nose bristled from the scent of a burning cigar. It was at this point that the most incredible paranormal event occurred. The spiritual cigar smoke flowed and moved into a metamorphosis of a human figure on the stairs leading to the second floor, and it was standing in the doorway. At the exact moment that this happened, the alarm on one of the video cameras started blaring, indicating that it had stopped working. Pictures were taken of this ghostly smoke man, yet the photographs revealed nothing. We had only the group's eyewitness

Todd Webster reviewing the safe, with an orb, at the Roscoe Conkling mansion.

testimony that this had happened. Dave went to check on the camera, and there was nothing wrong with it. The group and I felt that we had rattled Roscoe's cage with our line of questioning. This was a man and spirit that wasn't used to such directness, especially with him coming from an age of staunch decorum and personal etiquette.

Our next location to investigate was the basement. I always enjoy the basements of old mansions, for they host a variety of paranormal nooks and crannies that ghosts will hide in. Many of these older locations have stone foundations, artesian wells, root cellars and closed-off tunnels that sometimes had been used in the Underground Railroad or other escapist pursuits. The Landmark Society employees remarked to us that the basement was a scary place. I was excited about getting down there to see if we could capture some more paranormal interactions. Dave had reported, much like at Rutger No. 1, that there was a high creep factor within the basement. I went down into the basement with Ed and Marlene. Within moments, Marlene picked up on the presence of three spirits. They were men who had come to the mansion repeatedly in their mortal life to either rob the place or conduct some act of criminality. Marlene had visions of the men being there to rob the place—only two got out alive while one was left behind. It was at this point that Kathy took a photograph of a shadowy figure standing in the corner of the basement, partially hiding behind an oil tank.

We went up to the second floor, and Marlene and I came face to face with a full-blown ghost. On the second floor, there is a long hallway that at the end had a door, behind which was a narrow staircase. I descended down this dark and dusty stairwell, with Marlene right behind me. We were only a few steps down when Marlene stated that there was somebody in there with us. It was at this point that we could see a full apparition of a man in farmer jeans and a brim hat standing on the landing in front of the door. We halted, and I couldn't believe how clear this farmer was. I could tell that he wasn't malicious but rather a caretaker of this place. All of a sudden, *poof*—he was gone. Marlene and I walked all the way to the bottom of the stairs to the landing, where there was a beautiful door that was locked and that we couldn't open. Later on, we discovered that this was the servant entrance to the kitchen.

As we continued our investigation on the second floor, we had several more K2 spikes, as well as strong EVPs, especially in the bedroom that Roscoe Conkling had occupied. It was rumored that Conkling would practice all of his political speeches in front of the mirror in his second-floor bedroom, so it makes sense that it would have spiritual words coming

An entity forming in a mirror at the Roscoe Conkling mansion.

into our dimension to be recorded. We did have a strange occurrence in the back corner room on the second floor. I and others had taken some random digital pictures throughout this room, including into the mirror to try and catch a ghostly reflection. However, when we examined some of the digital pictures, the reflections of some of the ghost seekers were not there. This room was also a place where a distinct EVP of a spirit said to us, "Ah ha!" Marlene had also picked up a spiritual presence in the room. I asked, "What are you?" and caught on our digital recorder a spooky voice from the other side that replied clearly and loudly, "Spirit." Another EVP was captured when the group was having a general discussion with the digital recorder running and got back a voice that was not from anybody in our mortal realm that made a shuffling noise and responded with, "Excuse me." But all of these EVPs paled in comparison to the evil and malicious one that we captured that stated, "Get out!"

We had an interesting experience in a small room that is right off Conkling's bedroom. The size and location would indicate a nursery. The

door to the room was small and easily opened. Kathy, Marlene Marrello and I went in there and had strong feelings of a presence. This didn't seem like a big deal until we went to the fundraiser and mentioned to the Landmark Society employees of us going in there. They were stunned and said that this little door had never been opened and had always been frozen shut. It was as if the spirits were asking us into the nursery.

The most dangerous paranormal interaction of the entire investigation came when Marlene, Ed, Dave and I were looking into a large walk-in closet that was on the second floor in Roscoe's master bedroom—Marlene was forcefully pushed from behind by a spirit. Ed was directly behind her and couldn't believe the force of the interaction. This was not a residual haunt but rather an intelligent haunt. This ghost did not want our interference.

I was thrilled with how haunted Rutger Mansion No. 3 was and couldn't wait to get up to the third floor to see if our paranormal good luck would hold. Marlene, Kathy and I went up together. Earlier in the evening, Marlene had picked up on a mischievous little spirit girl that she sensed was wandering the mansion. In fact, Marlene had seen this little girl skipping, and this was repeated and witnessed by Kathy when we were up on the second floor. A cute paranormal interaction occurred when the little girl physically contacted Marlene. The three of us had concluded our investigation on the third floor and were leaving when this little girl reached out and grabbed Marlene by the back of her pants and attempted to yank her back to her play area. It was just a little gesture that let us know that she was a fun and curious little girl, yet I felt sadness wondering if this child were lonely for a playmate and needed to move on to her final plane of existence.

I was impressed with the sheer amount of paranormal interactions that I and everyone else had at Roscoe Conkling's mansion. We had everything, including electronic voice phenomena, orbs, ectoplasm, direct physical spiritual contact and other unexplained phenomena. Both Rutger Mansion No. 1 and Rutger Mansion No. 3 are bookends of paranormal excellence.

On Saturday, October 16, 2010, Mike Bosak had a fundraising event for the Landmarks Society and asked us to conduct a walkthrough of Rutger Mansion No. 1 and No. 3 for those patrons curious to hear of our findings. We posted individual team members in different rooms and would explain the evidence that we collected. We were having groups of fifteen to twenty people at a time coming into the mansions, hearing our tales and seeing our evidence from both investigations. Even with all of these people in attendance, we had several occurrences of spiritual interaction. We had the K2 meter light up when one of the guests asked about their dead

grandmother and if they were there. All in attendance gaped at the reaction from the spirit world. Then, when we took a group into the walk-in closet off Roscoe's bedroom at Conkling's mansion, the location where Marlene was pushed, we had people being poked, pushed and pinched by an angry spirit. We had one young man who was scratched while he was in this closet; he took pictures when he got home of these scratches and e-mailed them to me. On top of all of this, lights were going on and off all over the place. There's no doubt in my mind that Rutger Mansion No. 1 and No. 3 are among the most haunted locations I have ever investigated.

SARATOGA COUNTY HOMESTEAD

Barkersville—The investigation at Saratoga County Homestead proved to be the most chilling and frightening one I've ever conducted. My journey into this dark paranormal experience began one day when my son came home from work and explained to me that he had seen a large, abandoned brick structure that he thought the Ghost Seekers team should investigate. My son is very uncomfortable with spirits and the entire ghost-seeking experience. I respect his views, so I was surprised that he would put his uneasiness behind him to stop off and look over a possible location to be investigated. He stopped with a friend from work and walked just inside this abandoned structure. He was apprehensive, and when he was inside, he and his friend became distressed and had a very uneasy feeling that caused them to bolt from the place. As soon as my son got outside, he snapped some random pictures of the exterior and captured one of the most evil-looking pieces of haunted evidence I had ever witnessed. It was a large ectoplasm face in the window. I quickly determined that this was real, for the glass was broken, leaving out any possibility that this image was a reflection. This was captured in the middle of the day, so I could only imagine what malignance could be found in this structure under the moonlight.

I conducted some research into this large structure and discovered that it is currently called the Saratoga County Homestead. Another name for the building was the Homestead Sanitarium, and at one time, it was the location of a large tuberculosis facility, according to online sources. The homestead was opened in 1914 and treated ill tuberculosis patients until 1960. The original structure was wood and was replaced by the mammoth brick building in 1932. In 1961, the building was reopened as the Saratoga County Infirmary and also, possibly, as a retirement home.

The face of a demonic entity in the window of the Saratoga Homestead.

I was unable to verify this second aspect, but there was no doubt that the building housed disease, misery and death for many decades. No wonder my son ran from the building.

I decided to go to the structure with my ghost seekers and see what we could find. The first thing I did was sit down with our psychic, Marlene, and hand her the photo that my son had taken. I asked her if she could give me an impression from it. I have to admit that I had trepidation, for I try to avoid evil places—the members of my team are not demonologists, and some dark doorways shouldn't be meddled with or opened by the living. I wanted to get Marlene's impression of the photograph. She held it between her hands and closed her eyes. "What are you sensing from holding this?" I asked. "I feel a deep sadness," replied Marlene. I asked her if she had felt anything negative or evil from the photograph, and she said "No, just sadness." This satisfied me that the Saratoga County Homestead would be a fantastic location to be investigated.

We made the date to conduct the investigation of the homestead on September 24, 2005. We pulled up to the building when it was still daylight out, and I marveled at the size of this place. With it hosting

tuberculosis and other sick and dying human beings, I got the feeling of a cornucopia of sadness. The sun was out, yet the building had a gloomy feeling to it. I felt a little uneasy; however, we had gone beyond the pale of return, so I decided to sally forth with my team and enter the ominous structure. When Carol, Marlene, Ed, Len, David and I entered the dwelling, it looked as if the place had been closed overnight, with papers and other items scattered throughout the wide hallway. The place had graffiti and beer cans all over, as if local teens had been using the building. We started out with Marlene using sage and rituals to cleanse the location. We then partook in our pre-investigation prayer. We give the promise to respect their dwelling and their spiritual station. When we finished, we began our investigation.

Right away, as we proceeded down the hallway, I detected a very strong odor that you might associate with the rotting carcass of a dead animal. It was putrid. Marlene noticed it and asked me, "Do you smell that?" Some ghostly locations and paranormal interactions can have smells to them, ranging from cooking food, flowers, perfume and, yes, death. This type of odor could only mean that no good had happened here. Interestingly, Len could not smell what the rest of us could, with Marlene even putting the collar of her jacket over her nose. We went from room to room and then broke up and spread out. The place was far too large for all of us to stick together.

We found a set of stairs that took us up to the second floor. There was a large, empty activity room up there that had a small stage. Since the building was old and abandoned, there was no electricity so we had to go mobile with all of our electronic gear. It was in this activity room that Len's video camera autofocus kept going in and out with no reasonable explanation. He caught some light streaks going through the room, and once we got back out into the hall, the camera problems ceased.

As we got toward the end of the large, wide hallway of the second floor, I noticed a set of stairs, which we took, that brought us up to the roof. When we got up there, I noticed what looked like a chapel that had been built on top of the roof. The structure looked like it had some sort of crucifix on it. The door was large and ominous looking. I was drawn to this strange building on the roof, so we proceeded over to it and went inside. There were no pews inside this structure. As it turned out, once investigated further, it was more of a maintenance building that housed the pulley and cabling for the institution elevator. Its exterior appearance had looked so much like a chapel, I had wondered if it had some spiritual use.

Right away Marlene felt a presence in the structure, so we all started taking snapshots in the hope of catching spiritual imagery. Marlene started to engage this spirit in conversation, and this interaction made us go completely quiet. This spirit was that of a little girl that said her name was Susan and that she had been there for a long time. Marlene told her that she needed to tell her story. Susan revealed that she had been abused very badly by the people who were caring for her while she was there. The abuse was so severe in the mortal world that this little girl was afraid to go into the light. She wanted to stay behind so she could tell somebody what had happened to her. "You must go into the light, Susan," Marlene had said. The emotion got so intense that Marlene had tears streaking down her cheeks. Marlene continued speaking to the little girl by saying, "You've told your story, Susan. It's time to move into the light. You don't want to stay in this dark, dirty, lonely place."

Marlene felt that for some reason the little girl was resisting—something was holding Susan back. It was as if there was a veil blocking the communication between Marlene and this little girl. It was at this point that Len suggested that we all gather together, hold hands and give this child permission to use our collective energy to pierce the veil and more clearly communicate with Marlene. The group did this, and we suggested together that she head into the light. "Move to the light, Susan," we chanted together, when suddenly, we all felt a terrific electric psychic jolt. The dread disappeared, and the mood lightened in the room. I didn't need Marlene to tell me or the group that Susan had indeed moved into the light. She was free of her dreaded confinement. After this event, Marlene marveled that she had not felt the little girl or the dread from the photograph. She had felt that it was disguised in order to lure us here for the purpose of freeing this little girl spirit. Susan had moved on.

We all went back downstairs into the main, first-floor hallway and then headed down into the basement in what was soon to become the most frightening paranormal interaction I have ever had before and since. The entire group descended ahead of me. I felt in great spirits with the release of the little girl, but all of this came to an emotional screeching halt once my feet hit the basement floor. I had a dreadful feeling of doom immediately, which stunned me, for I conduct these investigations with the entire purpose of interacting with the friendly otherworld entities, not anything dark or demonic. This was a new emotion to my personality matrix and confused me—I had a sixth-sense moment that I should not be in that basement. I felt enclosed and trapped, as if I had an itch I couldn't scratch or a hangnail

I couldn't pull. "It's just your claustrophobia kicking in," I told myself. I tried my hardest to penetrate deeper into the bowels of the basement when I spotted a black shadow in the deepest corner of the musty structure. This froze me for a brief second. The others were in front of me, marveling at a large industrial washing machine that must've been churning in the institutional life of the place. I was sure that they didn't detect my duress. It was at this point that my feelings hit a dreadful nadir, so I stated very loudly, "I need to leave this place!"

I thought I had said this in a loud voice, yet the group did not seem to react to my stress. It was as if the veil that had blocked the little girl was now keeping my mortal words from reaching the intended human ear targets. I yelled even louder with the request: "Will somebody please help me out of here!" I was scared as hell. I had never had such a feeling of dread in all my life. Carol heard me, came to my side and said that she would follow me up the stairs. Even when I got back upstairs, I still felt the same, so I ran for the front entrance, with Carol on my heels. My movements felt frighteningly slowed. I went down the front steps, and as soon as my feet hit the ground, the feeling snapped away. I was rattled. I was scared. My hands were shaking as I handed my cellphone to Carol and told her that she could call and get the other investigators out of there because I was never going back in there. Carol would not leave my side as I restated, "I will never, ever go back into the belly of this building...ever!"

After this investigation, time passed and a few days had gone by when Carol came to my home to see me. "I have to tell you something, Bernadette," she said with a worried look on her face. I knew that this had something to do with the Saratoga County Homestead investigation, so I invited her inside. We had been going through our collected evidence and had captured some more so-called people in the broken windows, which we knew was proof of the paranormal. Our EVP sessions had a lot of background spiritual communications yet no clear words that we could make out. We did have a clear spirit saying, "Ouch!" when we were in the large dining room. I still felt terrible about how I had reacted in the basement, until Carol revealed what she had come to speak to me about: when she was following me up out the basement, she saw that a black shadow mass had attached itself to my back. It flowed over my shoulders and pulsated as I fled. This malevolent spiritual leech frightened her as she kept behind me. Carol said that as soon as I stepped off the building and onto the grounds, *poof*—the entity disappeared.

I was overcome with emotion, and I cried. I said to Carol, "Are you kidding me?" Carol said that she couldn't tell me right away, as I was so

distraught and emotionally rattled. I felt that it was an elemental evil spirit. It was awfulness incarnate. At that time, I had said that I would never, ever go back. Recently, though, one of my ghost investigators asked me if I would ever return to the Saratoga County Homestead, and I said, "Yes. I'll go back." I'm not crazy. I didn't imagine this. There are dark things out there. They're spooky, and they can get after you. This is the reason why we sleep with the lights on. This is the reason why we pull the covers over our heads at night. My team and others have asked me why I would go back. It's very simple. This is what I do. I have to be brave.

APPENDIX I

GHOST GEAR

G host hunters and those who wish to explore the world of unexplained phenomena now have a multitude of technical equipment at their disposal. Basic needs include batteries, tapes, watches, extension cords and cellphones. The following is a list of tactical gear used in the field.

CAMERAS: Ghost hunters use both digital and traditional 35mm cameras and will take many pictures during an investigation. Most explorers of the paranormal claim that traditional film is better at capturing entities, mist and orbs.

CONTROL OBJECT: Placing a random object on the floor, table or counter and seeing if the spirit will move it is another way that ghost hunters seek proof of manifestation. This can be as simple as setting a flashlight on a counter and seeing if the spirit will light it or a penny on the floor to see if it moves.

DIGITAL RECORDER: Electronic voice phenomenon (EVP) are sounds and otherworldly voices that are recorded using a digital audio recorder. These devices can detect sounds out of the range of the human ear. During interaction with spirits, these recordings are considered voices from ghosts on another plane. A Class A EVP refers to a voice from beyond that is clearly recognizable as speaking without the aid of any digital enhancements.

DIGITAL VIDEO CAMERA: Ghost hunters will use a type of digital camera that has infrared capabilities and can capture ghosts in complete darkness.

The digital camera makes it easier for replay, to analyze potential evidence and also to debunk any false readings. Many times a camera will pick up images that the naked eye will miss. Shy ghosts have been known to make an appearance in front of a planted, unmanned camera.

EMF METER: High electromagnetic fields (EMF) can occur naturally in the presence of computer screens, cellphones or power lines. Sudden EMF spikes without an electrical explanation can signal the presence of a paranormal entity.

FLASHLIGHTS: All ghost hunters should have a portable flashlight and extra batteries. Spirits require extra energy to materialize and will drain batteries. This is an essential piece of safety equipment because investigations are often conducted in the dark.

INFRARED THERMAL SCANNER GUN: This hand-held device can be aimed and is used to pinpoint cold and hot spots. Many spiritual experiences are accompanied by temperature spikes.

K2 METER: This hand-held device has lights that will illuminate and flash to indicate that there is an increase in electromagnetic energy. The K2 EMF meter is a popular device with ghost seekers.

PHOTOGRAPHER'S VEST: A photographer's vest is a multiple-pocket vest worn by investigators during paranormal seeking. This garment holds extra batteries, flashlights, a K2 meter, digital recorders and many other accoutrements needed in ghostly investigations.

THERMAL IMAGING CAMERA: This camera is very popular with firefighters for locating people in buildings. It can also detect hot and cold fluctuations that can be caused by spirits.

TWO-WAY RADIOS: Ghost seekers have to investigate large buildings and need to stay in touch with one another. Also, in case of sightings, seekers have to verify with one another that there are no false alarms. Safety is another reason, as being in a dark building can pose hazards.

APPENDIX II
GHOST-SEEKING PROTOCOL

When you are in the field conducting a hunt for ghost and spirits, it's wise to use the standards and protocol that have been used by many groups that seek to archive the spiritual dimension, including the Ghost Seekers of Central New York. The following list of ghost-seeking protocol comes courtesy of the group, listed at its website, www.cnyghost.com.

These standards and protocol for conducting field investigations are based on experience and common sense. They establish a baseline to judge photos obtained by eliminating the common errors of most beginners. The Ghost Seekers of Central New York Standards and Protocol provide guidelines that ensure professionalism by ghost seekers.

- Ask the spirits of the dead for permission to take their photos or to record their voices.
- Respect posted property, ask permission and do not trespass.
- Always conduct your investigations in a professional manner.
- Show reverence and respect in cemeteries, battlefields, historic sites and so on.
- No running or horseplay in cemeteries or historical sites.
- A positive mental attitude is very important for all investigations.
- Follow the lunar cycles and solar storms for conducting investigations with best results. Paranormal events occur during peak geomagnetic field conditions.

- Do not take photographs during adverse weather conditions, such as rain, mist, fog or snow, or in windy or dusty conditions.
- Remove or wear the camera strap so it does not hang loose.
- Take photos of dust particles, pollen and moisture droplets to see how your camera records these kinds of artifacts that can produce orbs.
- An orb is not special or unique. It is only a description of shape. Most common orbs are airborne dust particles. Multiple orbs in photos are almost always dust particles, never spirits.
- Do not take photos from moving vehicles on dusty roads.
- Do not take photos while walking on dusty roads.
- Remove all dust, spots and fingerprints from camera lens.
- Avoid shooting into the sun as it results in lens flares.
- Avoid shooting with a flash at reflective or shiny surfaces.
- Keep fingers away from the lens of the camera.
- Keep long hair away from the lens of the camera.
- Avoid shooting when foreign objects are floating near the camera.
- Compare anomalous prints with negatives for confirmation.
- Flash is only good for nine to twelve feet from the camera, so focus on that range.
- Always use fresh audiotapes for tape recordings.
- If digital, record in one- or two-minute tracks.
- After about twenty minutes, the spirits will get bored, so there is no need to record longer in one area.
- Do not rub the side of the recorder while recording, and do not walk while recording. Stand still to record.
- We do not consider Ouija boards, dowsing rods, pendants or séances to be valid investigation tools.
- No smoking, drinking or drugs during an investigation.
- If someone is angry, they should not be involved with an investigation. They will draw angry spirits, and the other spirits will avoid them.

GHOST GLOSSARY OF TERMS

If you are going to be a ghost enthusiast and seeker, you need to know the general terms used in the field.

animism: a spiritual and religious belief that animals, plants and other entities, in addition to humans, have souls. Souls that belong to natural phenomena, geographic features and manufactured objects are also considered to be a part of this belief. The following believe in animism: Hinduism, Shinto and pagan followers.

aura: a field of radiation illuminating a person or object in the form of a halo, or aureole in religious art. Some feel that the detectable colors of the aura have meanings and depict an emotional state of being.

ectoplasm: a spiritual form of energy; ectoplasm is said to be associated with the formation of ghosts and also a factor in psychokinesis. Ectoplasm is a mistlike substance said to be made of ghosts or spirits and that enables them to interact in our dimensional plane.

electromagnetic field: a physical field produced by objects that are electrically charged. It affects the behavior of charged objects in proximity of the field. The electromagnetic field extends in space infinitely and describes the electromagnetic interaction. Ghost hunters believe that electromagnetic spikes are caused by spirits attempting manifestation.

electronic voice phenomena (EVP): sections of static noise or white noise recorded on digital or electronic recording devices that sound like voices speaking words to questions asked by paranormal investigators. Ghost hunters and paranormal researchers may interpret these noises as the voices of those from beyond the grave. Often, EVP is found in the scientific analysis after a ghost hunt has been conducted, most often in frequencies unable to be heard by human ears.

ghost: a spirit or soul of a dead person. A ghost is the apparition of a deceased person that is encountered in places they frequented, like their home or the place of their death—or in association with the person's worldly possessions.

intelligent haunting: a type of haunting in which the entity willfully participates and interacts with whoever is present. This is the soul of the person left behind, usually with unfinished business, the result of a tragic lifetime occurrence or the result of a murder. This is a rare form of a ghost, encountered by few ghost hunters. In some cases, a spirit may not realize that it is dead or that the love of this world holds it here.

orbs: round balls of light, energy or plasma that are quite frequently caught on videotape or pictures. Many orbs can be formed by atmospheric conditions such as rain, mist or dust particles. Some ghost hunters refuse to acknowledge the validity of orbs, while others are very selective and debunk what they can disprove, leaving some orbs as possible proof of an apparition. Sometimes, an appearance of an orb can be tied to electromagnetic fields and may represent the ghost trying to absorb power to allow itself to appear.

paranormal: a term that is used to explain experiences that are unusual and have no logical scientific explanation. In parapsychology, the term is used to describe the psychic phenomena of ghosts, ESP, telepathy and poltergeists.

parapsychology: research that investigates the existence and causes of psychic abilities and life after death, often with scientific methodology. Extrasensory perception, telekinesis and other mind manipulations have been studied by governments for years, with no full proof of evidence to suggest that such abilities exist.

poltergeist: a ghost that produces noise and moves objects through the air. Many ghost hunters have evidence on tape of items moving with no scientific explanation or rational means.

psychic: a person who has the ability to detect things hidden from the normal senses through ESP (extrasensory perception). The scientific community has yet to prove that psychic ability is a reality, yet scores of ghost hunters use psychics in their paranormal research.

residual haunting: a type of haunting that is like a videotape copy of a spirit that is left as an imprint on this world, destined to repeat the same event over and over, as if on an endless loop. A residual haunting doesn't interact with the living like an intelligent haunting.

DO YOU NEED HELP WITH YOUR GHOSTS?

If you are in need of spiritual assistance, please contact the Ghost Seekers of CNY at www.cnyghost.com. All communication is held in the strictest of confidentiality.

SOURCES

Beardslee Castle. www.beardsleecastle.com.

Burns, Paul. *Butler's Lives of Saints: New Concise Edition.* Collegeville, MN: Liturgical Press, July 2003.

Chester Gillette Trial. http://herkimer.nygenweb.net/herktown/gillette. html.

Ellen, Martha. "Group Seeking Buyer for Morley Heritage Gristmill." *Watertown Daily Times*, Wednesday, July 1, 2009.

Erie Canal Village. www.eriecanalvillage.net.

Foote, Allan D. *Liberty March: The Battle of Oriskany.* Utica, NY: North Country Books, 1998.

Ghost Seekers of Central New York. www.cnyghost.com.

Herkimer County Historical Society. www.rootsweb.ancestry.com/~nyhchs/ museum.html.

History of the Stanley Center for the Arts. www.cnyarts.com/about/history.

History of the Village of Herkimer, New York. http://village.herkimer. ny.us/content/History.

Hulbert House, 1812. www.hulberthouse.com.

Landmarks Society of Greater Utica. www.uticalandmarks.org.

Morley, New York History. www.morley.ny.us/morley_history.htm.

Old Stone Fort Museum, a Revolutionary War battle site. www. theoldstonefort.org.

Oriskany Battlefield State Historic Site, NYS Office of Parks, Recreation and Historical Preservation. http://nysparks.state.ny.us/historic-sites/21/ details.aspx.

Rizzo, Mike. "Reasons to Save Rutger Park as Deep as the City's History Itself." Op-ed. *Observer Dispatch*, December 5, 2007.

Rutger–Steuben Park Historic District and Rutger Park, Landmark Society of Greater Utica. www.uticalandmarks.org/rutger_park/rp_main.cfm.

Stanley Theater, Utica, New York. www.stanleycenterforthearts.com.

Village of Boonville, New York. "History." http://village.boonville.ny.us/ content/History.

Wikipedia. "Battle of Oriskany." http://en.wikipedia.org/wiki/Battle_of_ Oriskany.

———. "Chester Gillette." http://en.wikipedia.org/wiki/Chester_Gillette.

———. "Elbridge (town), New York." http://en.wikipedia.org/wiki/ Elbridge_(town),_New_York.

———. "Herkimer County Courthouse." http://en.wikipedia.org/wiki/ Herkimer_County_Courthouse.

———. "Herkimer County Jail." http://en.wikipedia.org/wiki/Herkimer_

County_Jail.

———. "Oriskany, New York." http://en.wikipedia.org/wiki/Oriskany_ New_York.

———. "Roscoe Conkling." http://en.wikipedia.org/wiki/Roscoe_ Conkling.

———. "Roxalana Flowers." http://en.wikipedia.org/wiki/Roxalana_ Flowers.

———. "Saratoga County Homestead." http://en.wikipedia.org/wiki/ Saratoga_County_Homestead.

———. "St. Johnsville (village), New York." http://en.wikipedia.org/wiki/ St._Johnsville_(village),_New_York.

———. "Utica, New York." http://en.wikipedia.org/wiki/Utica_New_ York.

———. "William Sprague (Rhode Island, 1830–1915)." http:// en.wikipedia.org/wiki/William_Sprague_(politician).

ABOUT THE AUTHORS

Dennis Webster lives, works, plays and scribes in the Mohawk Valley of Central New York. He has a Bachelor of Science degree from Utica College and a Master of Business Administration (MBA) from the State University of New York Institute of Technology at Utica/Rome. He's a member of the Mystery Writers of America, the Mystery Writers of New York and the Utica Writers Club. You can reach him at denniswbstr@gmail.com.

Bernadette Peck, founder and lead investigator of Ghost Seekers of Central New York, lives in Oneida, New York, with her husband, Dave. Her ghostly encounters as a child have led her to noted haunted places throughout her life, especially in New Orleans, Louisiana. She and her husband have two beautiful children and four precious grandchildren, whose curiosity about "ghosts" keep her ever vigilant of the "stay behinds." She can be reached at dpecksr@twcny.rr.com.

Visit us at
www.historypress.net